IMAGES
of America

OTTUMWA

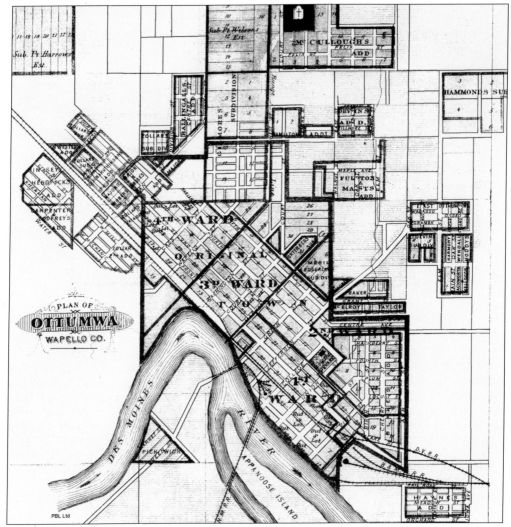

MAP OF OTTUMWA, 1875. Ottumwa's original development along the north and east sides of the Des Moines River, beginning in 1843, had clearly expanded by 1875. Several new additions further north would soon be added to the city, and by the 1890s south Ottumwa, the triangle marked here as Pickwick, would be incorporated into the city as development spread along Church Street.

IMAGES
of America

OTTUMWA

Michael W. Lemberger
and Wilson J. Warren

ARCADIA
PUBLISHING

Published by Arcadia Publishing
Charleston SC, Chicago IL, Portsmouth NH, San Francisco CA

Printed in the United States of America

Library of Congress Catalog Card Number: 2006929120

For all general information contact Arcadia Publishing at:
Telephone 843-853-2070
Fax 843-853-0044
E-mail sales@arcadiapublishing.com
For customer service and orders:
Toll-Free 1-888-313-2665

Visit us on the Internet at www.arcadiapublishing.com

For the people of Ottumwa, all of whom helped to make this history.

—Wilson J. Warren

For all those who have helped to preserve the story of Ottumwa.

—Michael W. Lemberger

CONTENTS

ACKNOWLEDGMENTS

The photographs in this book are selected from the collection of Michael W. Lemberger, which have been assembled from many sources. Our thanks go to the photographers now deceased who gave their negatives and prints, including Lynn Lancey, Dick Hofmann, "Skinny" Nimocks, and Norm Hill, and to friends who tracked down collections and information and in some cases purchased photographs and negatives at auction, including Karl Hoff.

Without LeAnn Lemberger's help, we could not have completed this book. LeAnn diligently fact-checked and expertly edited the entire text and suggested several useful sources. In addition, she contacted several local experts on Ottumwa's history for clarification or additional information.

I am grateful to Western Michigan University Library's Resource Sharing Center for efficiently providing me with several books I needed for references.

As always, my family, Jane, John, James, and Katherine, supported my interests and efforts and put up with my constant distractions.

—Wilson J. Warren

My thanks go to Sue Parrish, Molly Myers Naumann, Elsie Mae Cofer, Sr. Suzanne Wickenkamp, Sr. Donna Donovan, Ab Yochum, Jimmy Hemm, Pat Myers-Lock, Irene Weinberg, Bessie Ullman, Mike O'Hara, Betty Burdock, Bill Duree, Jerry Lee, and Bob Nandell; to the Wapello County Historical Society and Iowa State Historical Society for information and reference material; and to the Ottumwa *Courier,* whose news stories and historical articles from the 1890s to the present have been invaluable. Dr. Loren Horton and Dr. Donald Woolley were both inspirations, insistent that this book must be written.

—Michael W. Lemberger

Bill Warren may be contacted at Department of History, Western Michigan University, Kalamazoo, Michigan 49008.

Michael Lemberger may be contacted at P.O. Box 935, Ottumwa, Iowa, 52501-0935, or through his Web site at www.mlemberger.com.

INTRODUCTION

Nestled along the flood-prone Des Moines River in southeastern Iowa, Ottumwa has been one of the state's most important cities since its founding in 1843. By the time of the Civil War, Ottumwa had established itself as the commercial and industrial center of this portion of the state, a role that has changed little since that time. Perhaps more than any other factor, the Des Moines River has played a significant part in shaping Ottumwa's history. The river's periodic and often devastating floods not only damaged lives, homes, and businesses, but also influenced city and state politics, most notably by catapulting Herschel Loveless into the mayor's office in 1949, which then gave him a platform from which he was able to win the governor's office in 1956 and 1958. Loveless started his political career as a flood emergency director in Ottumwa, and then became a tireless supporter of flood control efforts on the Des Moines River while he served two terms as governor.

Early on, Ottumwa also became a leading meatpacking center, not only in Iowa but nationwide, by drawing upon livestock production in the surrounding area. In fact, Ottumwa has been home to significant meatpacking activity since 1850, a record of longevity that may be unmatched by any city in the United States. From 1877 to 1973, John Morrell and Company—a firm that originated in Bradford, England, in 1827 and was the fifth-largest meatpacking company in the United States for much of the 20th century—had its most important meatpacking plant in Ottumwa. In addition, the company's headquarters were located in Ottumwa until December 1955. For nearly a century, Morrell was the economic lifeblood of Ottumwa, employing thousands of area residents and directly impacting dozens of city and regional businesses. In the immediate post–World War II era, the Morrell plant was the third-largest factory in Iowa. Since the Morrell plant's closing in 1973, two other meat packers, Hormel and Excel (now Cargill Meat Solutions), have owned major plants in Ottumwa.

In addition to meatpacking, Ottumwa's major industries have included an important farm machinery manufacturer since 1900, the Dain Manufacturing Company (later the John Deere Ottumwa Works); several railroads until the latter part of the 20th century; plus dozens of smaller employers, including candy factories, bakeries, creameries, iron works, coal mining equipment manufacturers, cigar makers, brick makers, lawn mower makers, automobile parts makers, and telephone companies. Although Ottumwa has long been a major retail, wholesale, health service, and education center for southeastern Iowa, these functions, relative to manufacturing, grew during the latter part of the 20th century. At the beginning of the 21st century, Ottumwa had one of the area's larger retail centers, Quincy Place Mall; hospitals and clinics, the Ottumwa Regional Health Center and Ottumwa Clinic; and community colleges, Indian Hills.

Since the late 19th century, Ottumwa's cultural contributions have also been notable. The Ottumwa Opera House, opened in 1891, was a major center for culture, entertainment, political events, and other community attractions until 1940. During the Great Depression, a new coliseum-armory opened, and served similar functions as the Ottumwa Opera House until it was torn down shortly after the beginning of the 21st century. Today a new cultural events venue, Bridgeview Center, is under construction and will no doubt draw residents from southeastern Iowa to its many attractions. The city hosts two symphony orchestras, the Ottumwa Symphony and the Southeast Iowa Symphony, and the Carnegie library now serves the population in ways the founders could not have imagined. The city's many fraternal and service organizations serve thousands of residents as well.

This photographic history of Ottumwa attempts to survey much of the city's evolution. It also highlights a few of the major unique elements of the city's history, particularly the Iowa Coal Palace and Industrial Exhibits of 1890 and 1891, and the Naval Air Station Ottumwa, which became a major training site for navy pilots during World War II. In all, this history attempts to convey the many important contributions the city and its residents have made to the region's development.

Welcome to Ottumwa!

One

FOUNDING
1842–1878

Before the 1840s, the Ioway, Sauk, and Meskwaki (Fox) Indians occupied the land that became Iowa, including Wapello County and Ottumwa. Between 1824 and 1851, however, pressure from white settlers resulted in federal government treaties that removed nearly all Native Americans from the state. The treaty signed with the Sauk and Meskwaki for a total of just over $1 million at the Indian Agency in 1842, just east of what would become Ottumwa, included not only later Wapello County but also much of central and south-central Iowa. The county was named for the Meskwaki chief Wapello, who had moved to what is now the south side of Ottumwa in 1838.

Wapello County and Ottumwa officially opened to settlement on April 30, 1843. Platted by the Appanoose Rapids Company, Ottumwa was located near the Appanoose Rapids on the Des Moines River, close to the site of the current Market Street Bridge. Consensus opinion is that the Native American word *ottumwa* translates as "swift water." Water provided transportation until railroads reached Ottumwa during the Civil War era, and swift water from numerous devastating floods tremendously influenced the city's development.

The town was named Louisville in May 1844, but was renamed Ottumwa in November 1845. During the town's first 30 years, agriculture and coal mining were its chief drawing points. Sawmills and flour mills were built in 1843, a hotel called the Ottumwa House in 1844, and the first courthouse in 1846. The town was incorporated in 1851, and by 1853, there were eight dry goods stores, two drug stores, one clothing store, two hotels, and two churches (Congregational and Catholic) as well as other small industries. In 1860, Ottumwa's population reached 1,632.

In 1859, the Burlington and Missouri River Railroad, which became part of the Chicago, Burlington and Quincy Railroad, reached Ottumwa. The Civil War era also saw growth in what would soon become the city's manufacturing mainstay, meatpacking. Ottumwa's first meatpacking facility was the James Hawley and Sons plant, which opened in 1850. Various firms operated meatpacking facilities from then until 1877 when John Morrell and Company began operations in Ottumwa.

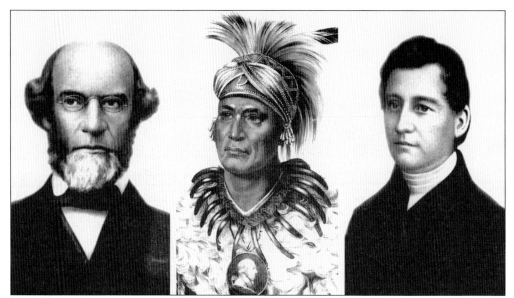

Maj. John Beach, Chief Wapello, Gen. Joseph Street. Maj. John Beach (left) hosted the October 1842 council that resulted in the Sauk and Meskwaki's sale of much of central Iowa. Chief Wapello (center), namesake for the county, had earlier refused to sell, but after he died, his people sold their land. In 1838, Gen. Joseph Street (right) established the Indian Agency, now known as Agency, near what would become Ottumwa. He died on May 5, 1840.

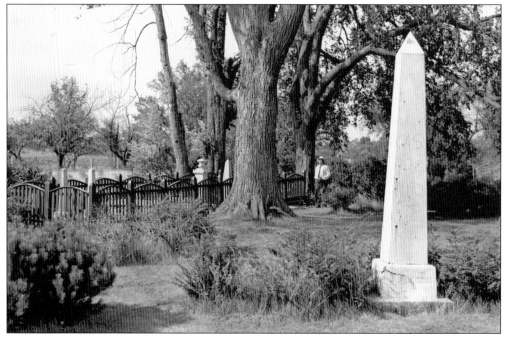

Chief Wapello's Grave Site in the 1930s. In the background, Wapello's great-grandson Nokawata is visible. Wapello requested that he be buried near his good friend General Street, who had died two years earlier and was buried near the Indian Agency he had founded, just a few miles east of Ottumwa. Major Beach and other family members are also buried in the plot, which is still maintained as a historical site.

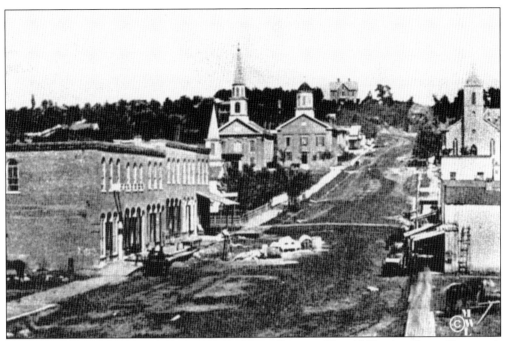

LOOKING NORTH UP COURT STREET FROM MAIN STREET. This 1860s view shows Ottumwa's central business district on the north bank of the Des Moines River. Further north, on the west side of Court Street, are the Methodist Episcopal Church (later the armory), and the city's second courthouse, closest to the corner. St. Mary of the Visitation Catholic Church, built in 1860, is on the right. Central Park development has not yet begun.

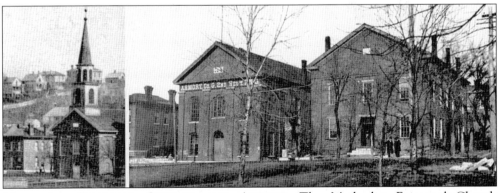

METHODIST EPISCOPAL CHURCH AND ARMORY. The Methodist Episcopal Church (photograph at left, about 1865) later became the armory headquarters for Company G, Second Regiment of the Iowa National Guard. The photograph at right, taken about 1878, shows the armory and the start of development of Central Park. The building to the right of the armory is the county's second courthouse, built in 1855. The two buildings occupied the site of the present courthouse.

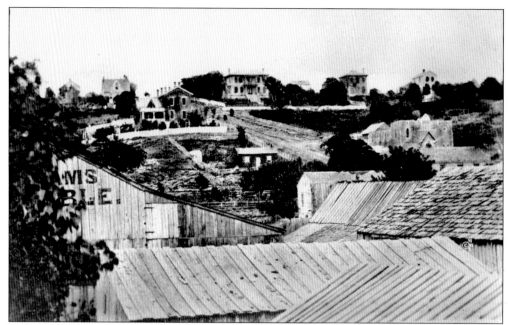

MARKET STREET HILL, LATE 1860S. This view from the central business district looking northeast up the Market Street hill illustrates the hilly terrain of the city's near north side. Note the half-built St. Mary's Episcopal Church at center right, at Fourth and Market Streets. The log cabin in the center of the photograph is thought to be St. Nicholas, the city's first Catholic church, which church records indicate was located near Fourth and Market Streets.

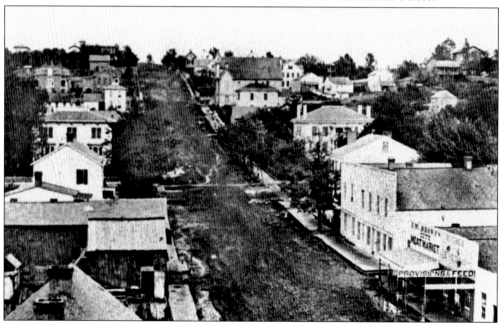

GREEN STREET, 1860S. This photograph shows the residential area just north of the main commercial section of Ottumwa, looking northeast from Main Street. The hilly terrain and wide dirt streets of the town are clearly visible. Prominent local businessman Joseph H. Merrill's home was located at the top of the hill on the left side of Green Street.

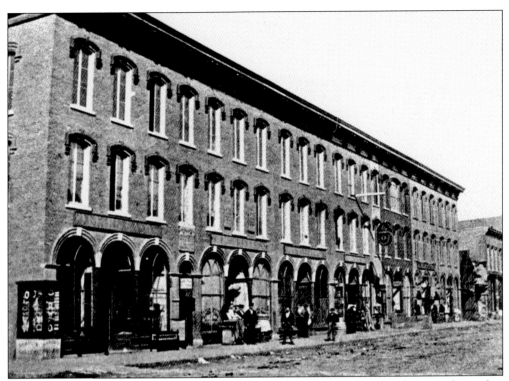

KITTREDGE AND MERRILL, 1860s. Founded in 1858, this wholesale grocery business, located in the so-called Union Block on the south side of Main Street between Green and Market Streets, became J. H. Merrill and Company in 1865. Its location moved several times over the next 50 years before the business became Samuel Mahon and Company in 1916.

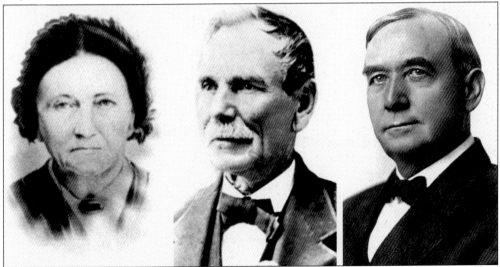

MARY TALLEY, GEN. JAMES SHIELDS, AND J. J. SMITH. Mary Talley contributed to the Sisters of the Humility of Mary, who named their first hospital after her. Shields, Mary Talley's cousin, was the only man to serve as U.S. senator from three different states. Shields died during an 1879 visit to Ottumwa. J. J. Smith, an in-law of Shields, was grand knight of the local Knights of Columbus council, named for Shields.

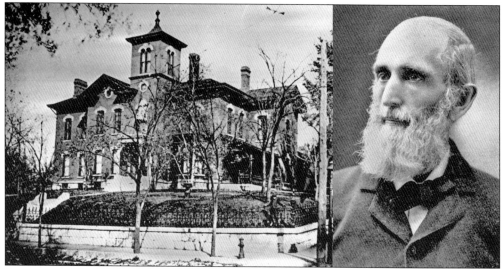

BONNIFIELD HOUSE AND WEST B. BONNIFIELD. Private banks existed in Wapello County from at least 1850, but when West B. Bonnifield arrived in Ottumwa in 1859 from the California gold fields with savings of $2,500, he invested in what later became the First National Bank. Bonnifield was initially a cashier but served as president until 1908. On the left is Bonnifield's home at Second and Jefferson Streets, built in 1869.

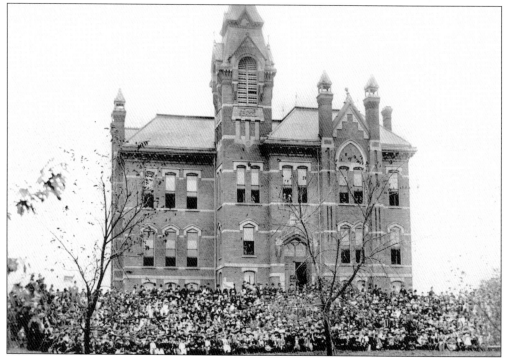

THE SECOND ADAMS SCHOOL, 1883. This photograph was likely taken during the dedication of the second version of Ottumwa's first brick schoolhouse. The original was built in 1865 at a cost of nearly $29,000. The first building, originally known as College Square, was renamed Adams School in 1870. It was torn down and this building erected in 1883. The Adams School existed on the site of the present-day high school building.

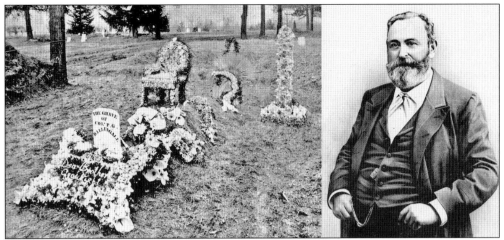

PETER GALLOWAY BALLINGALL AND CEMETERY PLOT. Born in Scotland, Peter Galloway Ballingall arrived in Ottumwa in 1859, the same year as the Burlington and Missouri River Railroad, and opened the New Depot Hotel. He was involved in nearly every civic project in Ottumwa during the late 1800s. He died at sea near Hong Kong in 1891, and the photograph on the left shows his grave in Ottumwa Cemetery shortly after his burial.

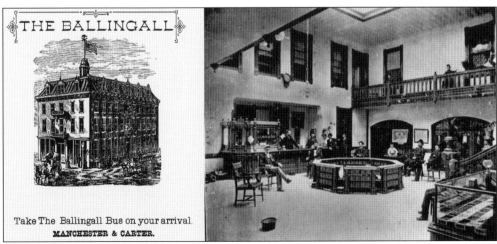

BALLINGALL HOTEL. Ballingall built the Ballingall House, said to be one of the finest hotels in the West, in 1864 at Main and Green Streets. The advertisement is from 1882 and the rotunda photograph from about 1890. Manager J. Manchester's name is on the glass at the registration desk at left. Note the spittoon on the floor in the foreground and the boxes of cigars in the case at lower right.

15

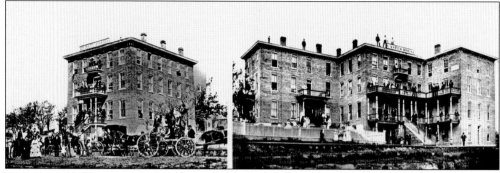

DR. CASTER'S HOTEL AND INFIRMARY. Dr. Caster's Hotel and Infirmary was constructed in 1874 (left) and had new wings added to it in 1875 and 1876 (right). In 1894, he sold the property and it later became the first Ottumwa Hospital. After Ottumwa Hospital moved to Second Street, the building became an apartment house. The Caster family owned nearly the entire block bordered by Main, Cherry, Second, and Birch Streets.

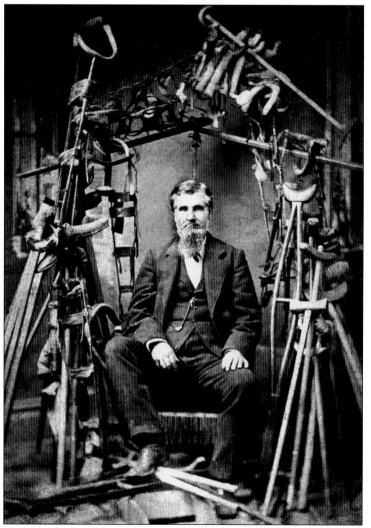

DR. PAUL CASTER. Although he had a limited education, Dr. Paul Caster became a well-known healer, and in the words of one historian was the most famous magnetic or rubbing doctor Iowa has ever had. This studio portrait shows him with discarded crutches and canes that his patients apparently no longer needed.

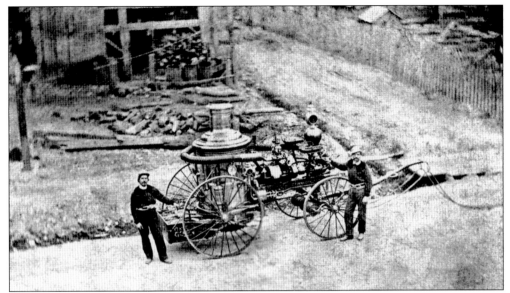

SILSBY STEAM ENGINE, 1870S. Ottumwa's volunteer fire department was formally organized in December 1868, though it had existed informally before then. By 1878, there were four fire stations located in the city, with Station No. 1, located at the city hall, having this No. 2 Silsby steam engine available as a reserve in case of a failure of the general water works's power.

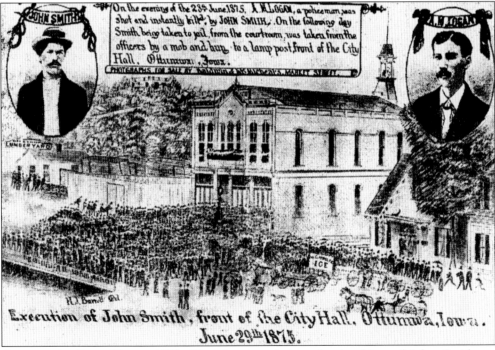

OTTUMWA'S CITY HALL, 1875. This drawing depicts the lynching of John Smith on June 29, 1875. Smith shot and killed a city policeman, A. M. Logan, on June 28. As Smith was taken from the courtroom to jail the following day, an angry mob seized him and hung him in front of city hall. The fine print says that photographs of the lynching were available from Baldwin and McMicheal's, Market Street.

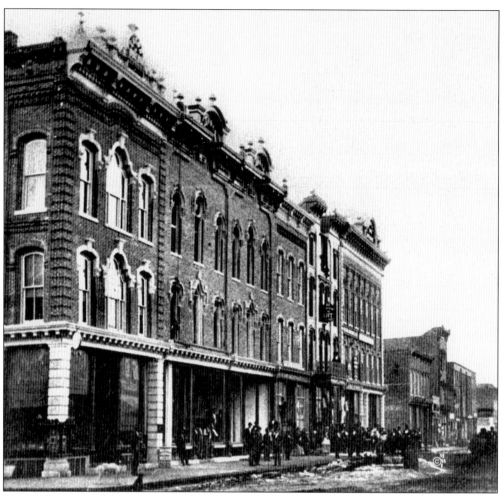

UNION BLOCK OF MAIN STREET. This photograph shows the reconstructed Union Block after the 1873 fire led to extensive remodeling. Note how much more ornate the building's facade is, compared to the 1860s-era photograph on page 13. The Union Block burned for three hours on January 22, 1873, starting in the third story of W. A. Jordan and Sons. The total loss was $142,000, an immense figure at the time.

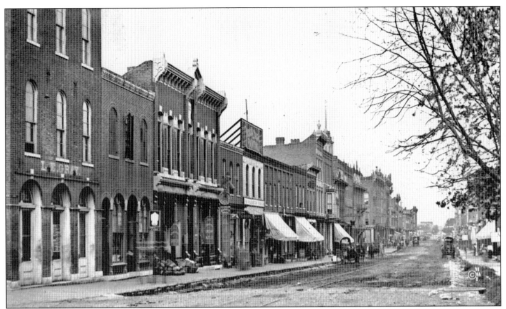

EAST MAIN STREET, C. 1870S. The photograph at top, taken from Jefferson Street toward Green and Market Streets, shows the south side of Main Street, including A. P. Peterson Grocery and a secondhand store, J. G. Smith and Company. Beyond the third awning is the Ballingall Hotel with its mansard roof, and across Green Street just beyond the hotel is Union Block. The bottom photograph shows East Main Street from Market Street looking toward Green and Jefferson Streets in the same period, again showing the south side of the street. Union Block is just left of center. Note the gas street lamps. In 1870, E. A. Swift and Company was organized to provide gas service. The following year it reorganized as the Ottumwa Gas Light Company and service began on January 1, 1871.

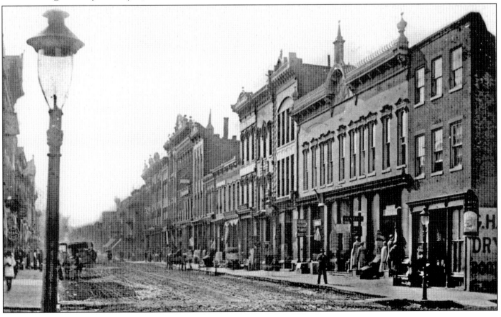

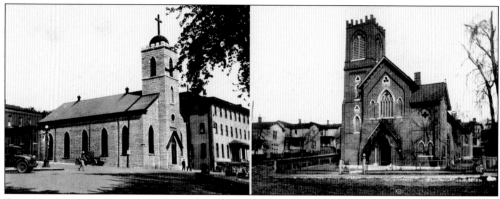

CATHOLIC AND EPISCOPAL CHURCHES. St. Mary of the Visitation Catholic Church, left, at North Court and Fourth Streets, was built in 1860, replacing an earlier brick building. This photograph is from the 1920s. The Episcopal congregation was organized in 1857 and laid the cornerstone of St. Mary's Episcopal Church (right) at Fourth and Market Streets in 1865. This building became the Christian Science church in 1899. A drive-through bank is now on the site.

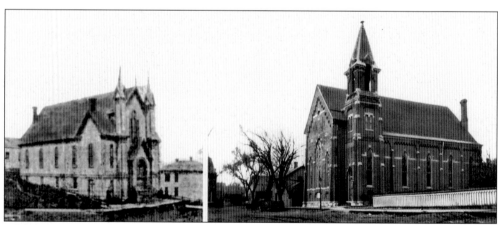

PRESBYTERIAN AND BAPTIST CHURCHES. The original First Presbyterian was erected at Fourth and Marion Streets in 1856. The second building (left) was located at the corner of Green and Fourth Streets in the 1870s. The original First Baptist was erected in 1862 at Fifth and Court, but in 1875, the congregation moved to 123 West Third Street (right). This building later became the YWCA and then the Knights of Columbus hall.

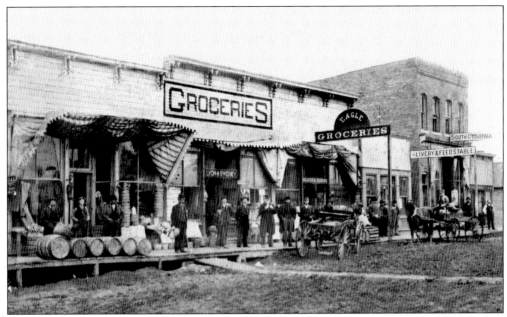

CHURCH STREET, 1870s. By the 1870s, South Ottumwa, known originally as Pickwick, had a distinct identity. Church Street, although still dirt-paved, was the main thoroughfare for Ottumwa's south side, an important retail and wholesale center for the approximately 600 people who lived in this part of the city by 1890. Lyon and Sweeney, Eagle Groceries, and the livery and feed stable line Church Street.

DOUGLAS SCHOOL. Ottumwa's second brick schoolhouse was built on the city's west side in 1870 and named Fourth Ward School. The school's original capacity was 215 students. It was enlarged in 1875 and renamed Douglas School. Note the trolley tracks in the street and the plank sidewalk.

LADD'S
Pork House,

OTTUMWA, DEC 18, 1877.

Owing to the location of the Pork House, a large portion of the citizens of Ottumwa have hitherto-fore found it inconvenient to avail themselves of the advantages offered by the Pork house Market. To accommodate this class, and fully sati-fied at the same that a Market more centrally situated would meet the convenience of the citizens generally, we have rented

Bonnifield's New Building,

No 15 Main St., 4 doors east of the Iowa National Bank, which we have opened as a First-class Meat Market, where we are selling all kinds of

PORK,

FRESH and CURED, at prices that cannot be equalled in the city.

No Meat Retailed at the Pork House.

Call and examine our stock and compare prices Yours Respectfully,
JOHN MORRELL & CO.
Pork Packers and Provision Dealers.

Retail Prices:

Tenderloins, 7c. Pork Trimmings 5c.
 Saueage, 8c. Spare Ribs, 3c.
Roasts of Pork, 5c. Pork Chops, 6c.
Lard, leaf and rendered, 9c.
 Salt Pork, 9c.

nov 15-dtf-wtilmar 15

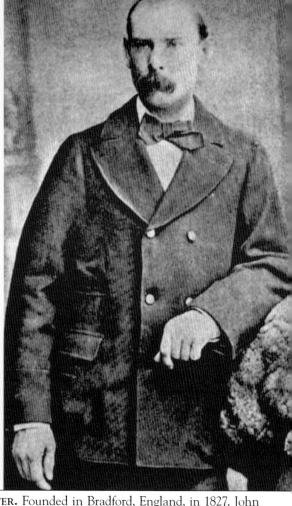

MORRELL ADVERTISEMENT AND T. D. FOSTER. Founded in Bradford, England, in 1827, John Morrell and Company became one of the largest meat packers in the United States. In the summer of 1874, Thomas Dove Foster, later president of the company, traveled throughout the Midwest looking for sites for a new packing plant. He returned to Ottumwa in the summer of 1877 and leased the former J. D. Ladd and Company packing plant for Morrell's initial operations, opening in November 1877. Morrell opened its own plant the following year. This was Morrell's first advertisement in the *Ottumwa Daily Courier*. Foster had worked with his father in Castlecomer, Ireland, where Morrell had established a branch plant in 1855. There he supposedly saw a box of bacon marked Ottumwa, Iowa, U.S.A. and later claimed the city's name stuck in his memory. This portrait was taken about 1876.

Two

GROWTH
1879–1903

Ottumwa was poised for growth after the Civil War. The city's population reached 9,004 in 1880 and 18,197 by 1900, making it Iowa's ninth-largest city. Commercial and residential development and infrastructure expanded with gas lighting and waterpower. The Ottumwa Water Works built a canal known as the race, with a series of dams and water wheels connecting a meandering loop of the Des Moines River along a direct path near the city's central business district. More public schools were built, and by 1889, Ottumwa had electric streetcars, making it one of the first cities in the country with this service.

Railroads were central to Ottumwa's growth and emergence as one of Iowa's leading industrial cities during the last quarter of the 19th century. After the arrival of the Burlington and Missouri River Railroad (later the Chicago, Burlington and Quincy Railroad) just before the Civil War, the Chicago, Milwaukee and St. Paul (usually called the Milwaukee) and Keokuk, Des Moines and Minnesota, or KDM Railroad (part of the Rock Island), arrived in the 1880s. The Milwaukee would become the city's second-largest employer (after Morrell) by World War I.

In addition to meatpacking and railroads, Ottumwa's list of industrial facilities by the beginning of the 20th century included icehouses, steam laundries, candy factories, bakeries, creameries, iron works, coal mining equipment and hay tool manufacturers, cigar makers, and brick makers. The Iowa Coal Palace and Industrial Exhibits of 1890 and 1891 signaled Ottumwa's emergence as a prominent Iowa manufacturing and commercial center. Ottumwa's cultural and social life prospered with a new YMCA building, the Ottumwa Opera House, and an Andrew Carnegie–funded public library. Boating, bicycling, and horse racing flourished.

Not long after the turn of the 20th century, Ottumwa suffered its worst flood in its half-century history. Eight thousand of Ottumwa's nearly 20,000 citizens were driven from their homes when excessive rainfall in May 1903 caused flood damage estimated at $100,000, an amount equivalent today to more than $10 million. The high water crest of the river in Ottumwa reached 24.5 feet, a level that was four feet higher than the great flood of 1947.

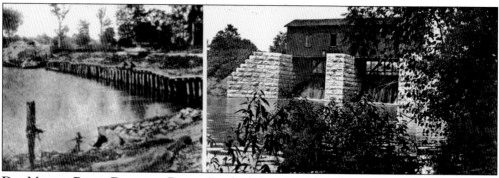

DES MOINES RIVER DAM AND RACE. On the left is the original Des Moines River dam, built of logs. To the right are the gates of the mill race, or race, a canal that connected the sweeping loop of the Des Moines River. Construction of the race was begun in 1875 and the dams, gates, and water wheels provided water and waterpower for the city until after the beginning of the 20th century.

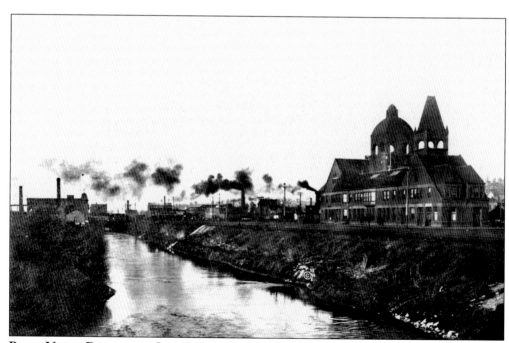

RACE, UNION DEPOT, AND COAL PALACE TOWER. This view shows the mill race in about 1891, with the recently completed Union Depot to the right. Although from this angle the depot appears to have two towers, the rounded tower to the left actually belongs to the Coal Palace, located northwest of the depot. The race was used until after the end of the 19th century.

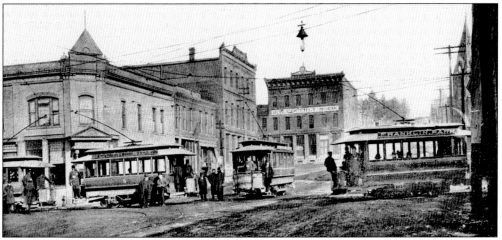

ELECTRIC STREETCARS. This view of the busy, but as yet unpaved, intersection at Market and Second Streets shows some of the electric streetcars that started service in 1889, including the South Side and Franklin Park trolleys. The streetcar service was initially operated by W. R. Daum, who also provided electric lights and steam heating to the downtown area. By 1906, the streetcars were operated by Ottumwa Railway and Light Company.

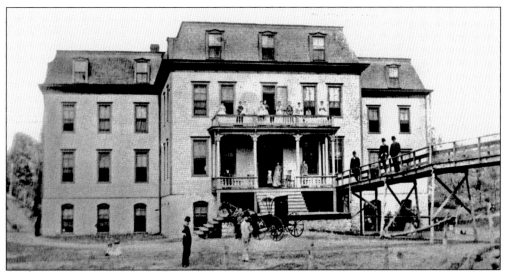

MINERAL SPRINGS HOTEL/INFIRMARY. L. E. Gray, a Wapello County sheriff, drilled an artesian well on Vernon Avenue one block north of Main Street and built this hotel in 1880. Trains brought guests to drink and bathe in the spring water, which contained sulfates of magnesia and iron and was used to treat patients suffering from rheumatism and stomach problems. The hotel was destroyed by fire in 1892.

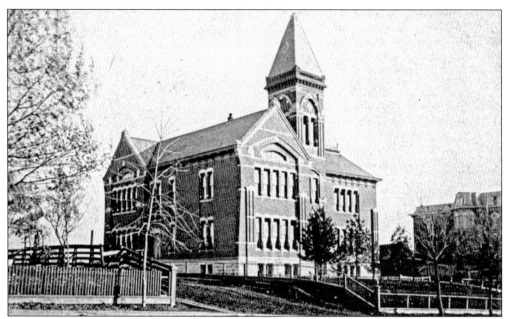

LINCOLN SCHOOL. The second Lincoln School opened in 1887 after a fire destroyed the first structure, which had been built in 1876. Located at the top of the hill on Court Street, the building served until it was replaced by a third Lincoln School in the 1950s.

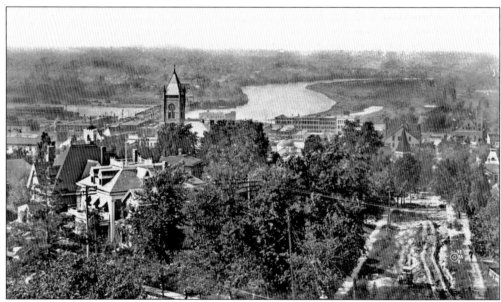

VIEW FROM LINCOLN SCHOOL TOWER. This view from one of the higher points in the city looks southwest toward the sweep of the river. Note the tower of the newly completed courthouse, with the Market Street Bridge leading to South Ottumwa behind it. To the right is Washington Street, still unpaved and showing ruts from buggy travel. Some of the houses to the left, along Court Street, still stand.

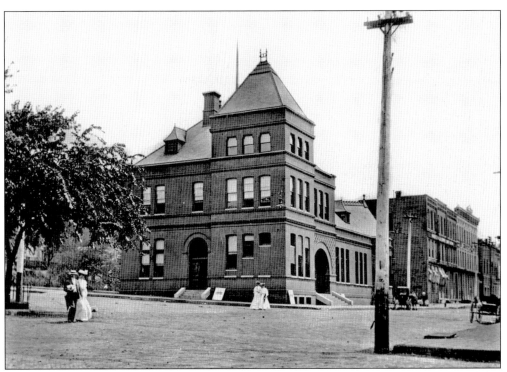

FEDERAL BUILDING. Post office facilities were located in various places around the city until this building, which included the city's post office, opened in 1889 on East Third Street just opposite Central Park, which is visible to the left of the photograph. Built at a cost of $40,000, it was used until 1910 when it was replaced. Delivery service started in 1889, with mail carriers sometimes riding trolleys and buses to get to their routes. The bottom photograph, of the building still under construction, shows workmen, including a plasterer wearing a white uniform. It was taken from the back or alley side of the building.

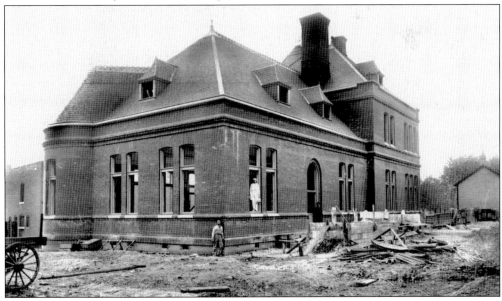

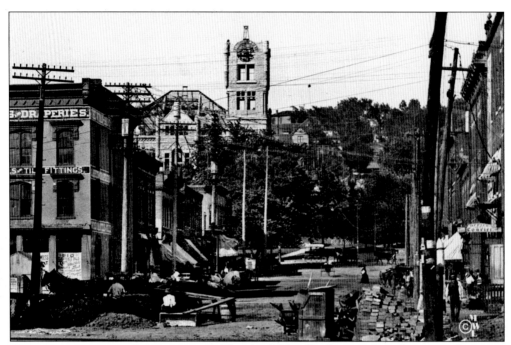

COURTHOUSE UNDER CONSTRUCTION. The third Wapello County Courthouse was begun in 1892 on the site of the previous courthouse and armory at Fourth and Court Streets. Note the steel framework of the roof and the incomplete tower in this view taken from the railroad tracks at Court and Main Streets. Meanwhile paving continued on Court Street (foreground), and Central Park construction was underway between Third and Fourth Streets.

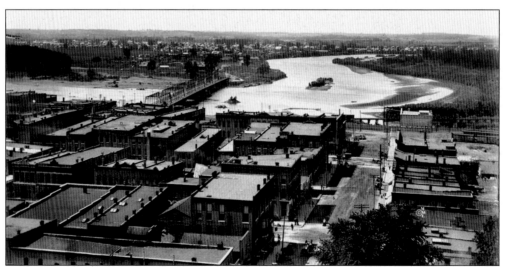

DOWNTOWN, FROM THE COURTHOUSE. The newly completed courthouse tower provided a bird's-eye view of the downtown commercial district. Ottumwa had clearly grown into a significant city by the 1890s. The Market Street Bridge, an all-iron structure built in 1892 that could also support the city's electric streetcars, and growing south side residences are visible in the distance.

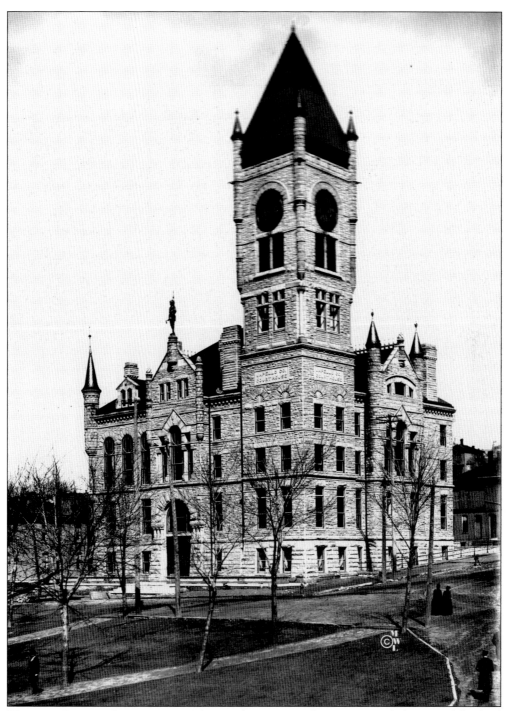

WAPELLO COUNTY COURTHOUSE. After nearly two years of construction, dedication of the third Wapello County Courthouse occurred in March 1894. Built at a total cost of $140,000, including $10,000 for the steam boiler system, the building was constructed of Berean sandstone with seven-foot-thick walls at the base of the four-story structure. The auditorium included three bronze chandeliers fitted both for electric and gas lights, and fireplaces were included in each room.

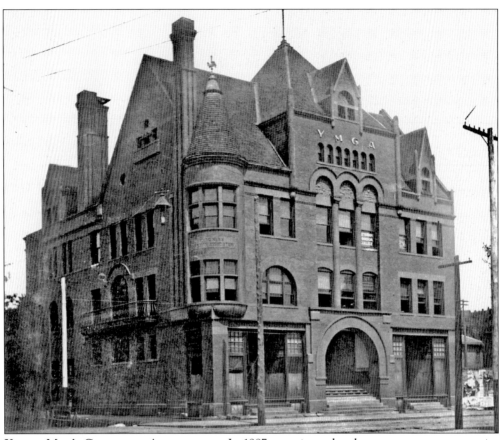

YOUNG MEN'S CHRISTIAN ASSOCIATION. In 1887, prominent local supporters met to organize the city's first YMCA chapter. The first building was at the corner of Main and Green Streets, but in 1890, property for a new building was purchased at Second and Washington Streets. This facility opened in 1891, and a gymnasium and swimming pool were added to it in 1902. The bottom photograph shows the prominent Ottumwa citizens who were part of the YMCA's board of directors in 1898. From left to right are (first row) A. D. Moss, James T. Hackworth, Thomas Dove Foster, Samuel Mahon, and William McNett; (second row) J. Peach, Charles Hallberg, Dr. E. T. Edgerly, Allen Johnston, C. J. Ekfelt, and Christopher Haw.

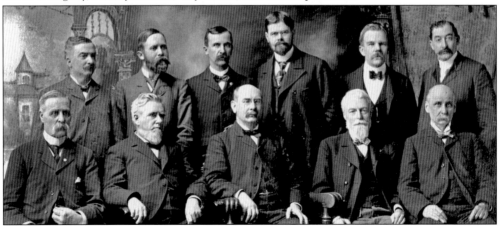

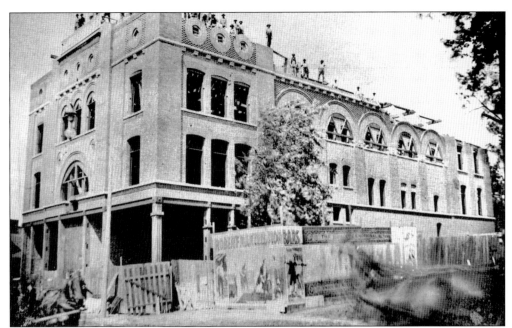

OTTUMWA OPERA HOUSE. Built at a cost of $50,000 and completed in 1891, the opera house was located at the corner of Main and Jefferson Streets. One of the city's premier cultural attractions, the building served as a site for political rallies, high school commencement ceremonies, and many other business and community events. Many of the era's most important celebrities and performers appeared here. Note the workmen standing atop the structure and the running horses in the foreground, blurred by the slow shutter speed required to take the photograph. The bottom photograph shows the interior of the opera house after the beginning of the 20th century, with a capacity audience of entirely women. In 1940, the opera house's top four stories were removed, and the building was renovated as a one-story building that would hold five different businesses.

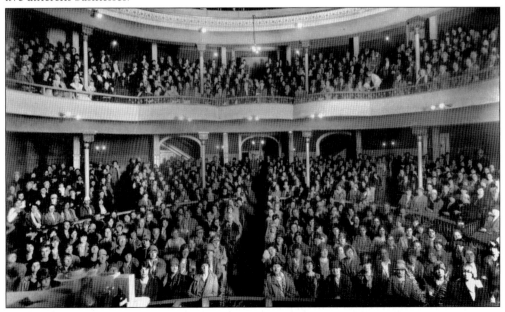

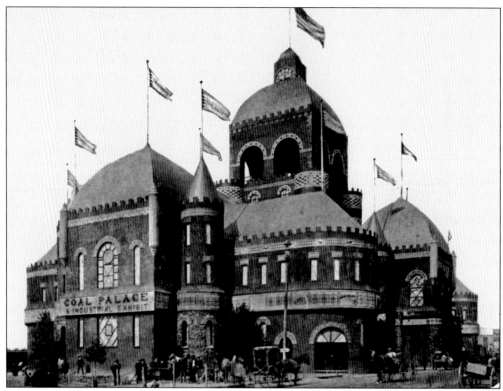

IOWA COAL PALACE AND INDUSTRIAL EXHIBIT. Inspired primarily by Peter G. Ballingall, the Coal Palace exhibit, open in 1890 and 1891, was an attempt to celebrate and promote the city's industrial growth and development. During the late 1880s and early 1890s, there were three other similar exhibition halls in Iowa, the Corn Palace in Sioux City, the Blue Grass Palace in Creston, and the Flax Palace in Forest City. Located just northwest of the recently constructed Union Depot, the Coal Palace was 230 feet long and 130 feet wide. Note the details printed on the ticket. The exterior photographs, showing the building from three directions, display the Byzantine-influenced architecture and coal veneer that cost $30,000, paid for by subscribers to the project.

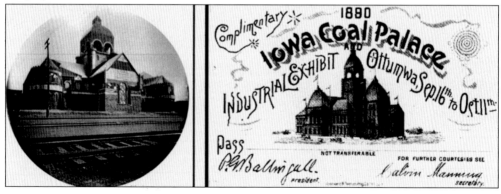

IOWA COAL PALACE AND INDUSTRIAL EXHIBIT. The Coal Palace included an auditorium that held 6,000 people, a sunken garden, and a working model of a coal mine. During the exhibition season, September to October in both 1890 and 1891, Ottumwa's and other southern Iowa cities' products were lavishly displayed. Among other dignitaries, Pres. Benjamin Harrison spoke at the Coal Palace in 1890, and Sen. William McKinley, who was later president of the United States from 1896 until he was assassinated in 1901, spoke there in 1891. McKinley (below, center, with hat at his waist) is shown just after getting off the train.

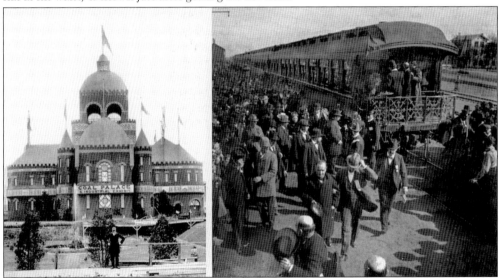

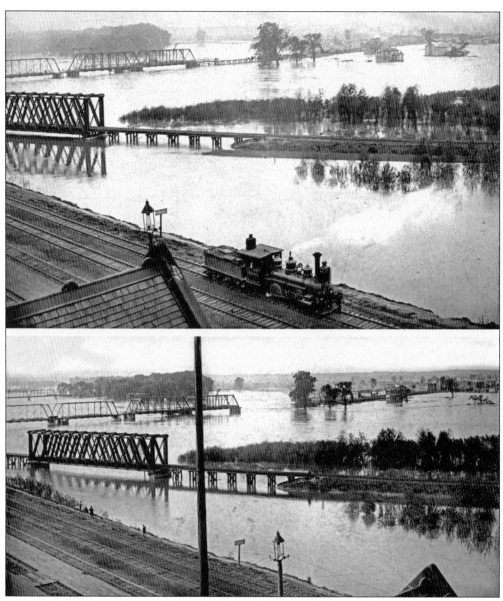

1892 FLOOD. These photographs, taken from the tower of Union Depot, show some of the damage caused by the rampaging river in May 1892. The top photograph shows the Market Street Bridge toward the top of the photograph, which was being rebuilt at the time of the flood. Note the two houses surrounded by water in the right background. In the bottom photograph, taken shortly afterward, the two houses have been swept away and have taken out the trestle approach to the bridge. The water closest to the depot is the race, while the water surrounding the houses is from the main channel overtopping its banks. The bridge section showing in the foreground is a railroad bridge, probably the Milwaukee line, and the engine is No. 410, with several people sitting on the cowcatcher.

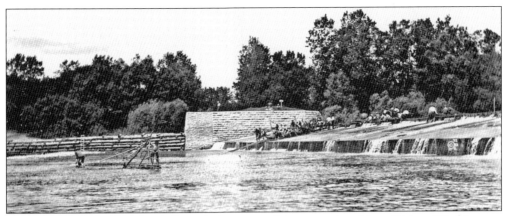

KELLEY'S ARMY. In 1894, Jacob Coxey led an army of the unemployed from Ohio to Washington, D.C., to petition the government for unemployment assistance, and Charles T. Kelley organized a protest march in Nebraska, intending to join with Coxey. Kelley's army was reported to include 1,000 men. Denied passage by train, they constructed flatboats for travel down the Des Moines River, reaching Ottumwa in May and encountering trouble crossing the dams.

SOUTH OTTUMWA, 1890s. Developed by Dr. W. B. Smith, who had inherited 200 acres from his father, South Ottumwa was annexed to Ottumwa in 1886. By 1893, there were more than 4,000 residents. On the left is St. Patrick's Church, built in 1880 and remodeled in 1890, at Church and Ward Streets. On the right is Irving School, built in 1886. Note the Des Moines River in the foreground.

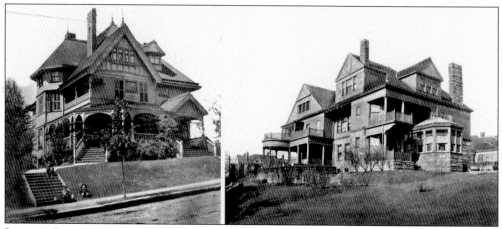

JORDAN, FOSTER HOUSES, 1890s. John C. Jordan, one of the owners of the Ottumwa Brick and Construction Company and a major contributor to the Coal Palace, lived at 419 North Court Street (left). Thomas Dove Foster, president of Morrell, built his house at the corner of Fifth and Market Streets in 1893. Despite the later addition of a stone facade, the house is listed on the National Register of Historic Places.

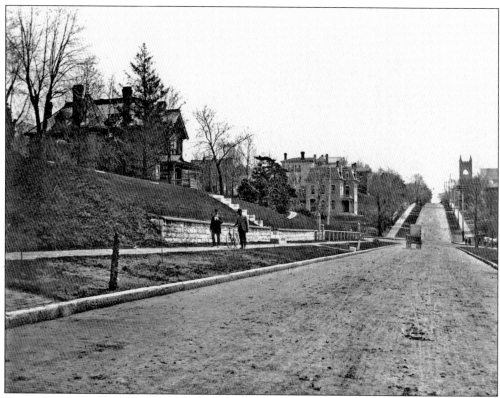

FIFTH STREET, 1890s. In the late 1890s, one of Ottumwa's more fashionable residential areas could be found along Fifth Street. In this view, looking southeast from a point near Washington Street, Trinity Episcopal Church, built in 1895, is visible in the right background. The cross street in the center of the picture is Court Street.

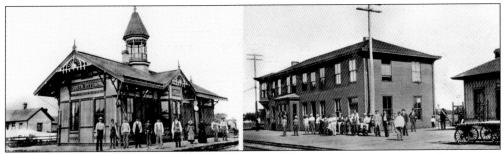

RAILROAD DEPOTS. After the Burlington/CB&Q Railroad made connections to Ottumwa in 1859, the city also became a major stopping point and operations center along the Rock Island and Milwaukee Railroads. Each line operated freight and passenger depots in the city. Both the Wabash and Milwaukee Railroads served South Ottumwa (left). The second photograph is the Milwaukee depot on Sherman Street.

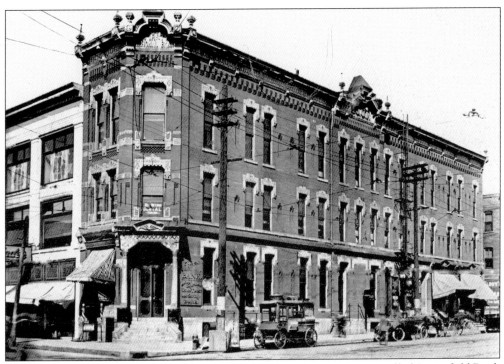

FIRST NATIONAL BANK. Ottumwa's first two-story brick building, the so-called Bonnifield Bank Building, named for banker West B. Bonnifield, was erected in 1849 at the corner of Market and Main Streets. After it collapsed in 1876, this larger building was erected on the same corner. The bank had become the First National Bank in 1863, the fifth bank west of the Mississippi River to be chartered under the National Banking Act.

JULIUS FECHT EMPLOYEES AND CIGAR BOX. German-born Julius Fecht arrived in Ottumwa in 1874 to work in cigar manufacture and opened a shop of his own in 1884. In addition to making cigars, he became a grower and importer of tobacco, owning a tobacco plantation in Cuba. There were about 20 cigar makers in Ottumwa in the late 19th century, and the industry operated on a smaller scale through the 1920s.

SCHAFER ICE. Before mechanical refrigeration, natural ice was stored in special facilities using sawdust as insulation. The A. L. Schafer Ice Company began in 1879 with a storage house that was 50 by 30 feet and could store 700 tons of ice hauled out of the frozen Des Moines River. Note the chute into the icehouse where horsepower was used to lift the ice into the building.

LOWENBERG BAKERY AND ANTON LOWENBERG. A native of Grinstadt, near Mannheim, Germany, Anton Lowenberg opened his first bakery in Ottumwa at 112 South Court Street in 1875 and remained in business at that location for many years. The photograph on the left shows this shop in 1895. In 1904, Lowenberg adopted the Mary Jane label for its bread, and also baked for many other labels.

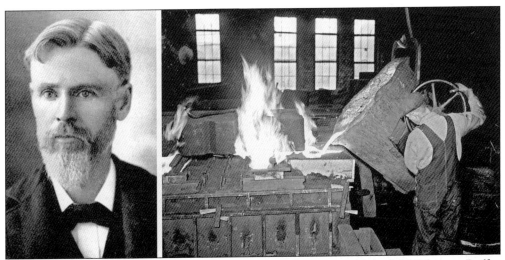

ALLEN JOHNSTON. The holder of 129 patents, Allen Johnston established the Johnston Ruffler Company in 1872, manufacturing sewing machine ruffling attachments for the women's clothing industry. The company employed about 500 men and women when sold to Griest Manufacturing Company in 1898. The iron foundry that was part of Johnston Ruffler then became Ottumwa Iron Works Company. Workers are shown at a later date pouring molten iron in the foundry.

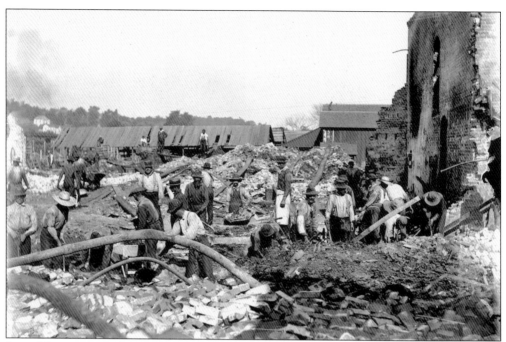

JOHN MORRELL AND COMPANY. These two photographs show the almost complete destruction of the Morrell meatpacking plant by fire on July 12, 1893. Although Thomas Dove Foster briefly contemplated moving the plant to Memphis, he decided to rebuild at the same location in Ottumwa.

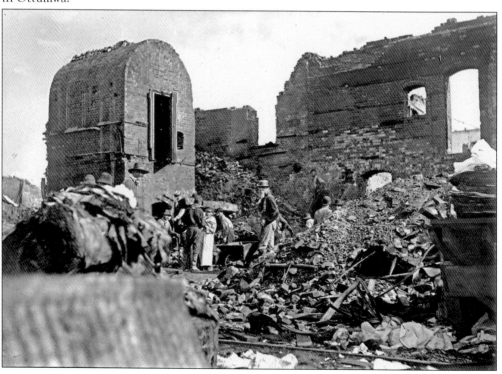

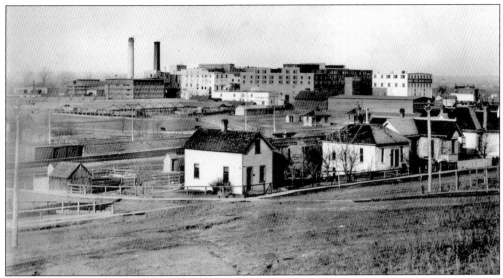

MORRELL AFTER THE FIRE. By 1900, the Morrell plant had been rebuilt and extended. This view from the north contrasts the size of the plant with houses in a nearby residential neighborhood.

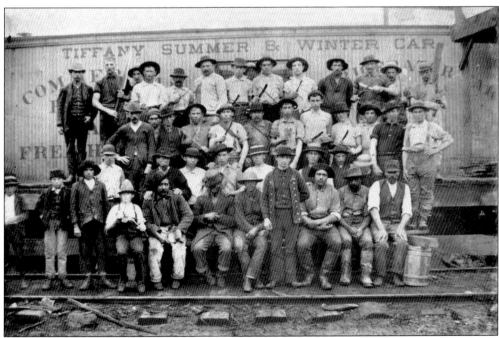

HOG KILL EMPLOYEES, 1888. Workers in the Hog Kill and Cut Department of the Morrell meatpacking plant display their knives, the most important tools of the trade. Note the number of boys working in the department. Morrell employed boys under age 16 until 1933.

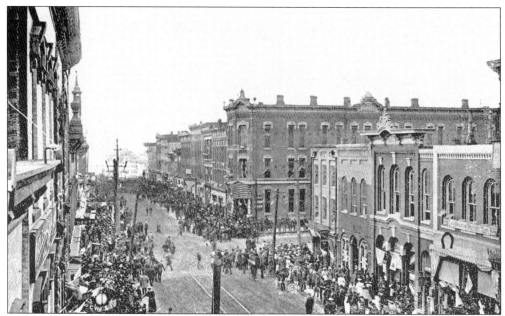

MAIN STREET. This photograph was taken from near the intersection of Main with Green Streets, looking northwest toward Market Street. The crowds are believed to be gathered for the 1889 centennial of George Washington's inauguration as the nation's first president. The three-story building in the center of the picture is First National Bank. Note the horseshoe sign marking a harness and tack business to the right of the photograph.

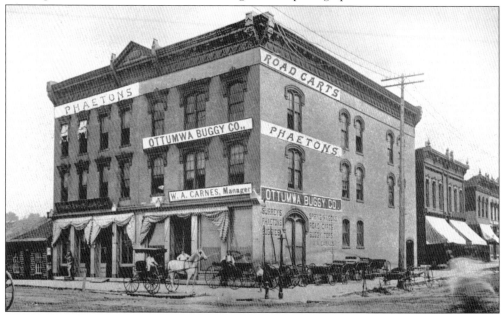

THE LAWRENCE BLOCK, 1880s. Built in 1880 on the northwest corner of Main and Court Streets, the Lawrence Block housed a Morey and Myers cigar-manufacturer outlet, with wooden–American Indian statue, and Ottumwa Buggy Company. Note the buggies for sale lined up on the sidewalk. To the far left is a small log cabin. To the right is a shoe store, located in a building that later housed Swenson's Bakery.

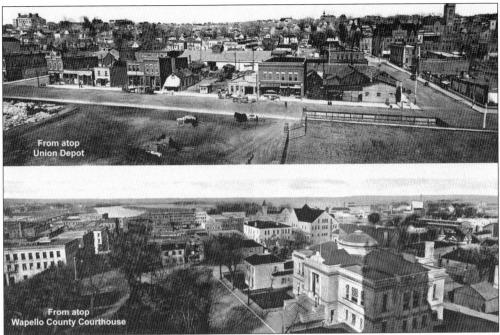

From atop
Union Depot

From atop
Wapello County Courthouse

DOWNTOWN OTTUMWA, 1903. The top panorama was taken from atop Union Depot. The YMCA and courthouse are in the right background and the new high school, completed in 1899, in the left background. This school later became Washington Junior High. The bottom panorama shows the public library, completed in 1902 with a $50,000 donation from Andrew Carnegie, on the right. The city's first library, formed in 1872, charged yearly dues until 1897.

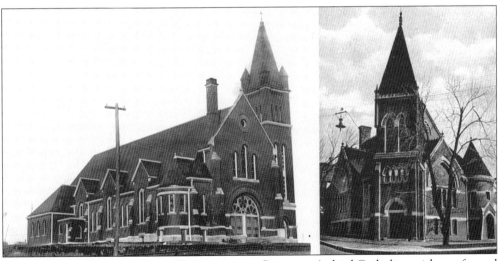

SACRED HEART CHURCH, FIRST PRESBYTERIAN CHURCH. A third Catholic parish was formed in 1897 and Sacred Heart Church (left) was erected in 1898 at 1105 East Second Street in Ottumwa's east end, with the rectory built in the following year. Sacred Heart closed in 1997. The third First Presbyterian Church (right) was built at Fourth and Washington Streets. It was dedicated in 1889 and served the congregation for more than 25 years.

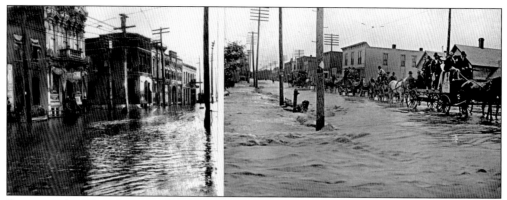

FLOOD, 1903. The May 1903 flood was the most damaging in Ottumwa's history up until that time. The photograph at top left shows Market Street, with the Corn Exchange saloon, also known as Stormy Jordan's "Road to Hell Saloon," to the left. Just beyond it is Emanuel Fist's hide and wool business, in the building that would become O'Hara Hardware. The photograph at top right shows floodwaters on Church Street as evacuees are taken from the commercial district toward Five Corners. Note the water pouring into the street from the river, just out of the picture to the left. The bottom photograph shows Union Depot after the water has started to recede, leaving debris behind. It was taken from Market Street looking southwest toward the race. Note the passenger train building up steam to leave the depot.

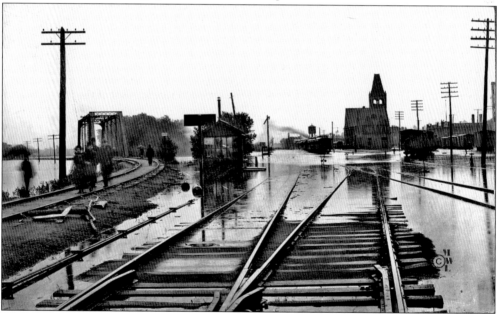

Three

DEVELOPMENT
1904–1921

The 1903 flood severely damaged Ottumwa, but the city recovered surprisingly quickly given that virtually all the city's major industries hugged the Des Moines River. When river water inundated the city's largest factory and employer, the Morrell plant, on Saturday evening, May 30, Thomas Dove Foster, company president, ordered workers to show up for work on Sunday, violating his own religious principles, in an effort to prevent the rising water from damaging equipment and meat in the plant. Workers moved meat from chilled cellars to higher floors and most of the company's products were saved. Although it took a week for the waters to recede, most of the city recovered within short order. In fact, between 1900 and 1910, Ottumwa's population grew by 21 percent to 22,012. By 1920, Ottumwa's population had reached just over 23,000.

Most of the industries that had characterized Ottumwa at the beginning of the 20th century had developed further by the beginning of the 1920s. Although workers had gone out on strike at the Morrell plant in 1921, part of a national strike wave during the period in the meatpacking industry, the company employed roughly 1,200 people, making it one of the largest factories in Iowa. In 1923, fifty-seven trains on five different railroad lines passed through Wapello County. The Milwaukee Railroad employed nearly 600 workers in the city at the beginning of the 1920s, trailing only Morrell in employment. The Dain hay tool manufacturing company, started by Joseph Dain in 1900, was purchased by John Deere and Company in 1910 and grew dramatically by the early 1920s. Other than the cigar-making industry, which declined through the 1920s, Ottumwa's array of mostly small but diverse industries, such as steam laundries, candy factories, bakeries, creameries, iron works, coal mining equipment manufacturers, and brick makers prospered during the first two decades of the 20th century. In addition, the first two decades of the 20th century saw the opening of much of Ottumwa's health care system, including Ottumwa Hospital, St. Joseph Hospital, and the Sunnyslope Sanatorium.

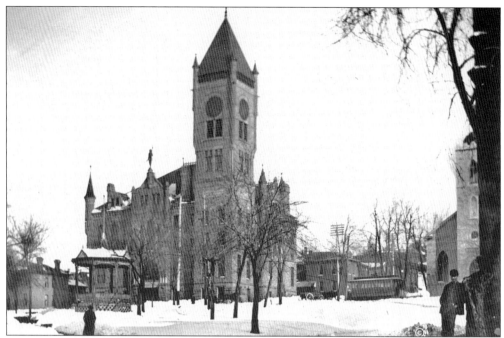

CENTRAL PARK IN WINTER. This shot from the early 1900s shows the Wapello County Courthouse, left, with St. Mary of the Visitation Catholic Church to the right. Note the streetcar on Fourth Street and the bandstand, one of several that were built in Central Park over the years.

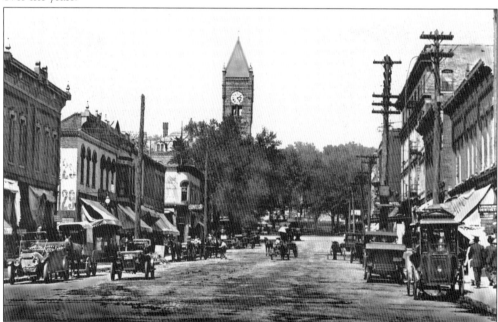

COURT STREET, LOOKING NORTH. A mix of horse-drawn vehicles and automobiles drive up and down the now-paved Court Street in this 1912 view, taken from the railroad tracks near Court and Main Streets. The Central Park bandstand in the center of the photograph appears to be different from the one in the previous photograph, taken just a few years earlier.

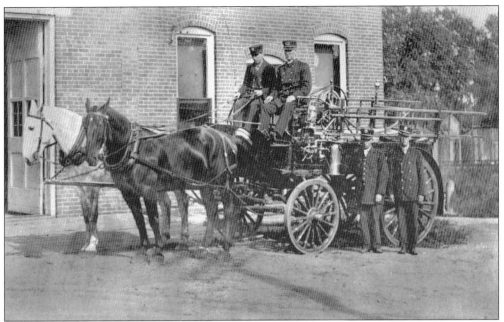

SOUTH OTTUMWA FIRE STATION, 1908. Fire department services expanded steadily between 1900 and 1910. The East End Fire Station opened in 1909, although, ironically, it was destroyed by fire in 1910 and then rebuilt. This crew at the South Ottumwa Fire station, Ransom and Church Streets, included Horace P. Williams (seated, left), Capt. John Shockley, pipe man Harry Skinner (standing, left) and Walter McGee.

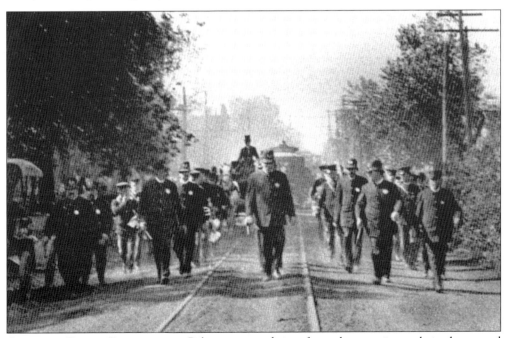

OTTUMWA POLICE DEPARTMENT. Policemen march in a funeral procession early in the second decade of the 20th century. Note the horse-drawn hearse near the center of the photograph, with the driver wearing a top hat, and the streetcar following the marching men.

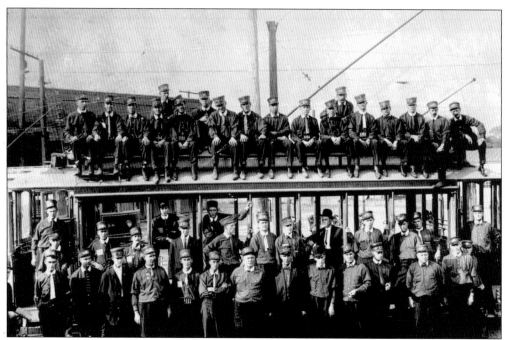

OTTUMWA RAILWAY AND LIGHT COMPANY. Horses or mules pulled Ottumwa's first streetcars, but in 1889, electric streetcars began operation, powered by a newly constructed steam-heating system that would diminish the city's dependence on waterpower. In 1914, Ottumwa had 12 miles of streetcar tracks and 34 electric-powered cars, operated by Ottumwa Railway and Light Company (ORLC). The top photograph shows employees posing on a streetcar about 1908. The ORLC building was located at Market and Second Streets (below, left). Car 67 operated from downtown up Court Hill (below, right). ORLC was purchased by Iowa Southern Utilities in 1925, and streetcars operated in Ottumwa until April 1930.

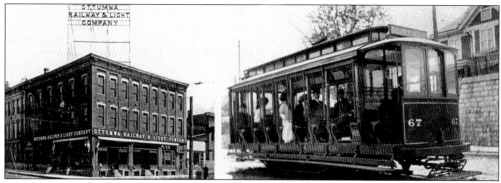

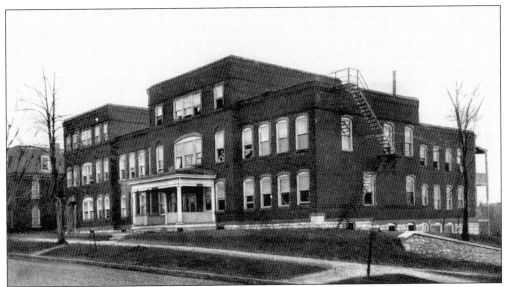

OTTUMWA HOSPITAL. Ottumwa Hospital owed its start to the members of the Mary Brooks Thrall Bible class of the First Methodist Church, who purchased Dr. Caster's Hotel and Infirmary for use as a hospital. This building was the second home of the hospital, erected in 1905 at the corner of College and Second Streets, across from the present-day high school. This view of the hospital is from about 1913.

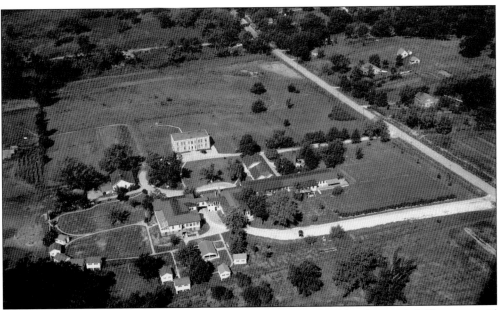

SUNNYSLOPE SANATORIUM. In 1916, the Health Committee of the Associated Charities paid $3,000 for Thomas Dove Foster's summer home, known as Sunnyslope, located about one mile east of the city, for use as a tuberculosis treatment facility. By the early 1920s, Sunnyslope was a well-equipped, 40-bed hospital. This aerial photograph shows the facilities as they appeared during the 1940s. Note the small cabins in the foreground.

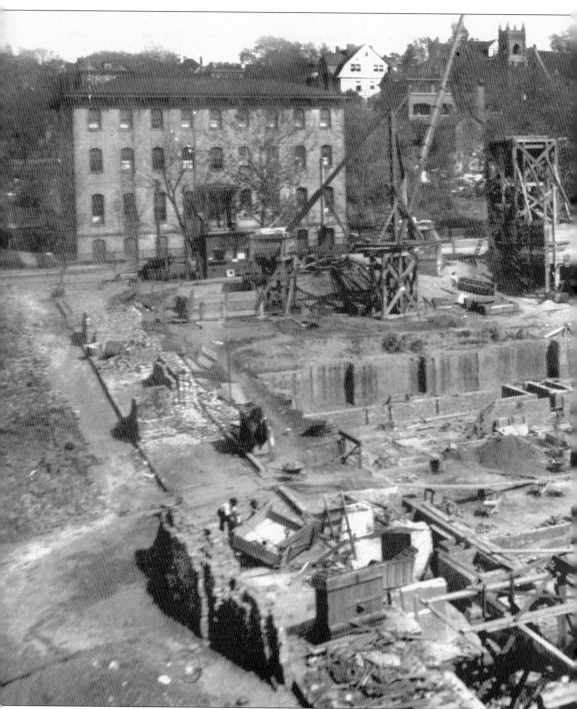

FEDERAL BUILDING CONSTRUCTION SITE. Although the previous brick federal building had served for only 20 years, by 1910 the city needed a larger facility, which was built on the same site across from Central Park. This view is of the construction site in September 1910. The building across the street, to the left of the photograph, is the convent and school of the Sisters of the Humility of Mary, which became St. Joseph Hospital in 1914. That building was later removed

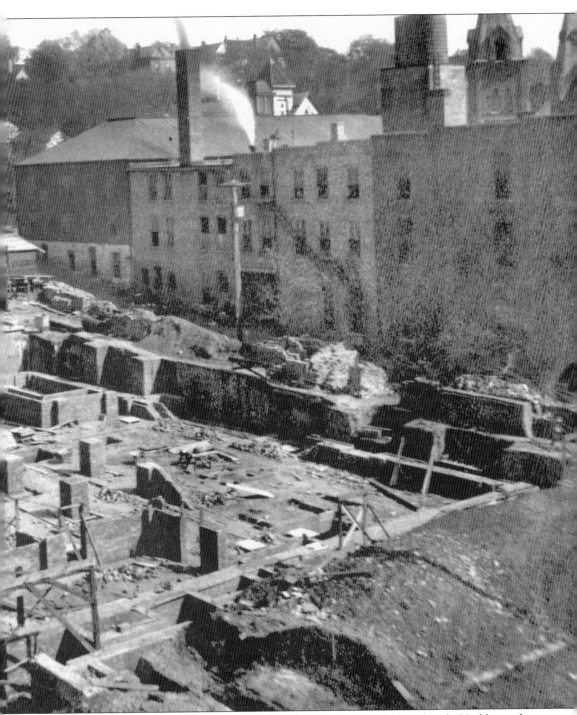

and the site is now a parking lot for St. Mary of the Visitation Catholic Church. Visible on the skyline are the towers of Trinity Episcopal in the center and First United Methodist to the right. Between those towers is the tower of the Church of Christ Scientist. The buildings to the right are Hall Candy Company, and the building in the center of the photograph is the armory where federal offices were moved during construction of the new building.

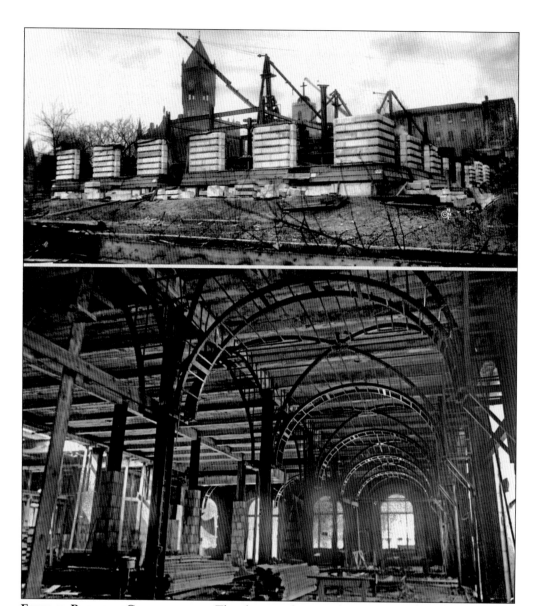

FEDERAL BUILDING CONSTRUCTION. The photograph at top shows the stone walls of the federal building going up in December 1910. The towers of the courthouse (left) and St. Mary of the Visitation Catholic Church are on the skyline. The lower photograph, taken in July 1911, shows the supports for the arched ceilings of the first floor and stone facing covering the support pillars.

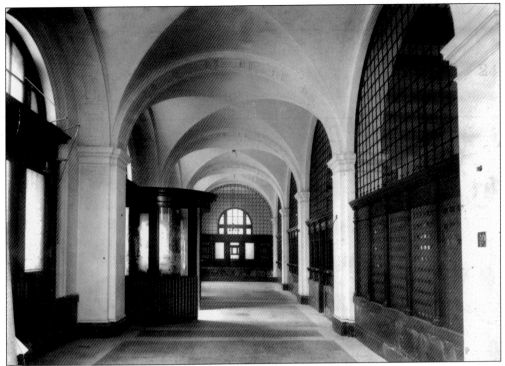

FEDERAL BUILDING. The top photograph shows a view of the building's interior taken May 3, 1912, showing rows of post office boxes. The first floor of the new building housed the post office until a new facility was built on West Second Street in the 1960s. Federal district court offices were on the second floor, including judge's chambers and marshal, inspector, and clerk offices. The third floor housed Internal Revenue Service offices, grand jury room, and federal highway commission offices. The bottom photograph shows the completed building as it appeared in about 1930.

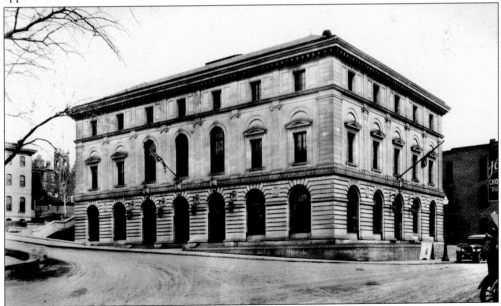

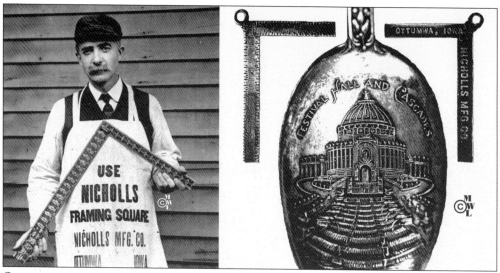

OTTUMWA AT THE WORLD'S FAIR. Ottumwa products were exhibited at the Louisiana Purchase International Exhibition in St. Louis, 1904, better known as the St. Louis World's Fair. At top left is Martin Hardsocg of Nichols Manufacturing Company. Although this photograph was taken in 1922, it shows the framing square that Hardsocg co-patented and that the Nichols Company produced during this era. The photograph at top right shows two Nichols squares given away as souvenirs at the fair, photographed with a souvenir spoon to show the very small scale. At the bottom left is the Nichols Manufacturing Company's ornate booth in the Iowa Building. At the bottom right is a Morrell advertisement from 1907 that proudly notes that the company was a grand-prize winner at the fair.

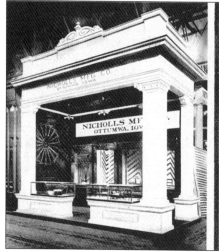 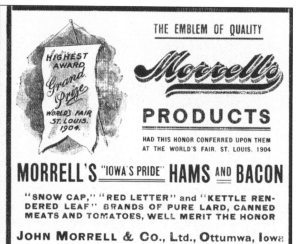

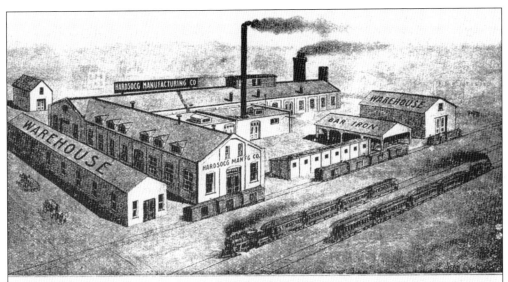

COAL DRILLS and All Kinds of MINERS' TOOLS and SUPPLIES
OTTUMWA, IOWA.

HARDSOCG MANUFACTURING COMPANY. Trained as a blacksmith, Martin Hardsocg became an expert in the care and making of mining tools. In addition to production of miners' pants, caps, oil lamps, and tools, in 1904, he began producing the Little Wonder pneumatic drill, used worldwide in rock quarries, mines, the Panama Canal, and the New York subway system. The plant, on West Samantha Street, produced mining tools until 1969.

OTTUMWA BOX=CAR LOADER!

From a Photograph of the Machine when At Rest Outside the Car.

WE MAKE A SPECIALTY of Machinery for Loading Box-cars.....We have made it a Success.
INVITATION IS EXTENDED to anyone interested TO VISIT OUR FACTORY.

OTTUMWA BOX CAR LOADER. W. E. Hunt from the Ottumwa Iron Works and Henry Phillips of Phillips Coal Company joined forces to develop a railroad boxcar loader for coal in 1896. Their production facilities were initially located on the corner of Main and Wapello Streets before moving to West Second Street in 1906. The company constructed a wide variety of equipment for the coal mining industry in the 20th century.

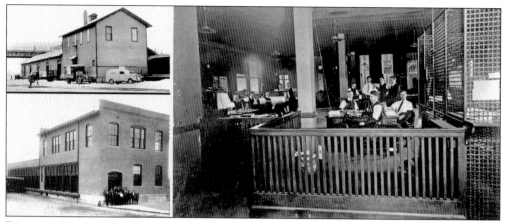

RAILROAD DEPOTS, OFFICES, AND YARDS. The Milwaukee Freight Depot, near the Jefferson Street Bridge, is pictured at top left. The Rock Island Freight Depot, at 212 South Union Street, is at bottom left. To the right is a photograph of the office staff of the CB&Q Freight House in 1915.

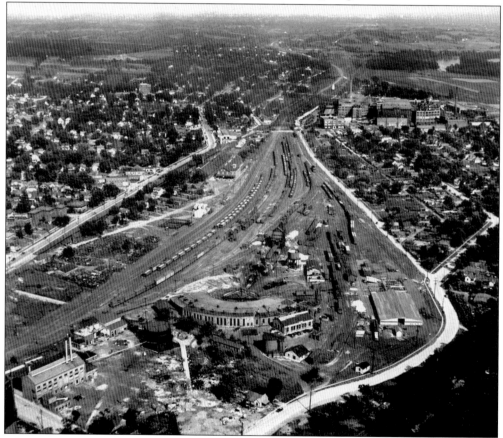

CB&Q ROUNDHOUSE. The Chicago, Burlington and Quincy Railroad roundhouse and switchyards at 300 South Vine served the Morrell meatpacking plant, top right. The coal chute is visible in the center of the photograph. At center left is Rosenman Brothers junkyard. Main Street runs up the left side of the photograph. At the bottom left is Vine Street, and Hayne Street is on the right side.

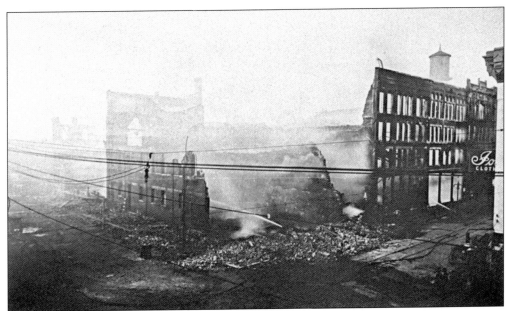

HAW HARDWARE FIRE, 1913. Started in 1864 by George Haw, Haw Hardware was twice destroyed by fire. After the 1868 fire that destroyed a large section of downtown, the business moved several times before moving to this building at 106–108 West Main Street. The building was destroyed by fire on October 20, 1913. Haw later moved to Third and Market Streets, and then to South Green Street in 1920.

THEO. A. STOESSEL, President A. T. STOESSEL, Vice Pres.
ALBERT T. STOESSEL, Secretary and Treas.

GARFIELD AND MADISON AVE
Ottumwa, Iowa.

Petroleum and Its Products

Illuminating Oils, Naphtha and Gasolines, Cylinder Stocks, Neutrals and High Grade Paraffine Oils. Dynamo, Gas Engine and Automobile Oils. Special Oils Compounded Under Our Own or Our Customers' Formula. Gas, Fuel and Road Oils

STOESSEL OIL. Organized in 1910, Stoessel Oil Works had its roots when Theodore A. Stoessel's grandfather began house-to-house delivery of kerosene in 1893. Stoessel's first kerosene trucks have been displayed at the Henry Ford museum in Dearborn, Michigan, and at the Museum of Science and Industry in Chicago. This advertisement from 1918 states that Stoessel was the only oil refinery in Iowa at the time.

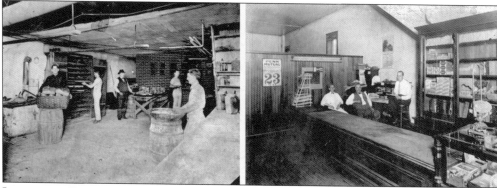

LOWENBERG BAKERY AND RETAIL STORE. In the photograph at left, employees are shown in the bakery. The man in the hat and vest at the center of the photograph is Anton Lowenberg, the founder of the business. The photograph at right shows the retail end of the business in 1911. In 1912, the bakery, then located at 120 East Second Street, installed its first automatic bread slicer.

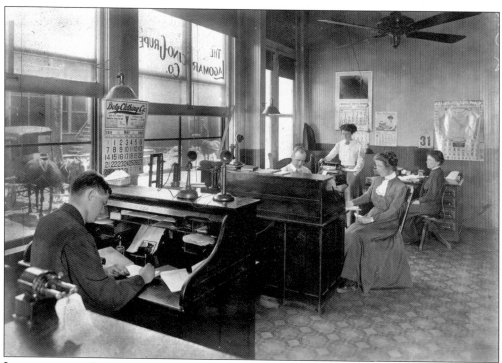

LAGOMARCINO-GRUPE OFFICE, 1911. Established in Burlington in 1875, this wholesale fruit, vegetable, and grocery business opened an Ottumwa branch in 1906. It was located at 212–214 Commercial Street in a three-story brick building that included cold storage mechanical refrigeration. By the early 1920s, the company employed 30 people and had sales of more than $1 million annually. Note the horses and buggy visible outside the windows.

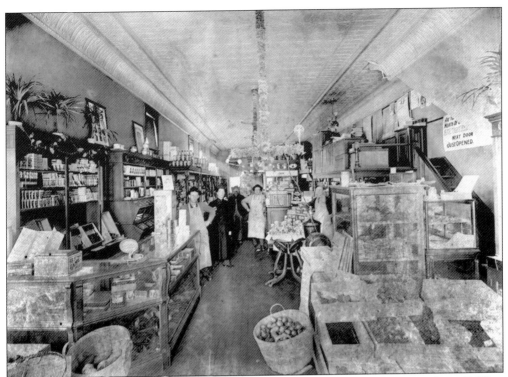

J. F. Ding Grocery. One of many neighborhood groceries, J. F. Ding was located at 402 West Second Street. This photograph is from about 1911. Note the workers' aprons and the baskets of produce, as well as the embossed tin ceiling and the unusually decorated light fixture at the center of the photograph.

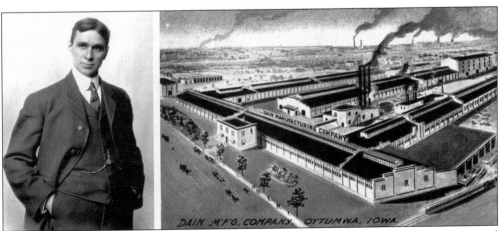

Joseph Dain, 1912. Joseph Dain's first hay harvesting machines were produced in Missouri, and he established the Dain Manufacturing Company in Ottumwa in 1900. Dain Manufacturing was purchased by John Deere and Company in 1910 and was known as the Dain Works until 1947. Joseph Dain worked for John Deere as a vice president until his death in 1917. The view of Dain Manufacturing is from a postcard dated 1911.

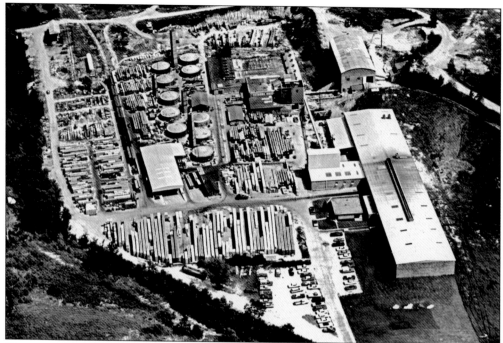

OTTUMWA BRICK AND TILE COMPANY. The Ottumwa Brick and Construction Company was organized in 1888. In 1890, the plant produced seven million paving bricks and four million building bricks. In 1911, it became Morey Clay Products Company. D. F. Morey designed and built a continuous kiln that was one of the world's largest at the time. The brick plant continued to operate until about 1990. This photograph is from the 1960s.

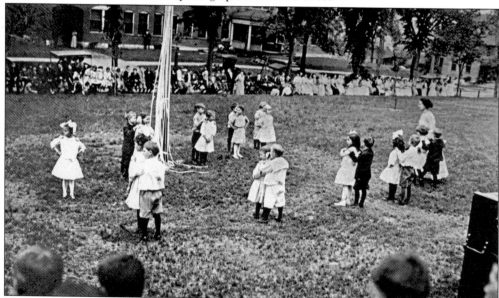

MAYPOLE DANCE. Children prepare to dance around a Maypole at the Adams School playground about 1910. Note the boys' sailor suits and the girls' hair bows. The little girl at left who appears to be standing alone is actually blocking the view of her partner. The Ottumwa Hospital is in the background.

60

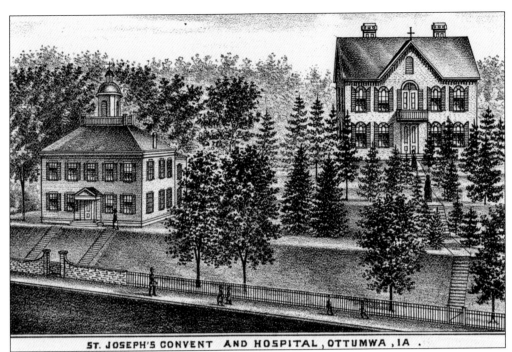

ST. JOSEPH'S CONVENT AND HOSPITAL, OTTUMWA, IA.

ST. JOSEPH'S HOSPITAL AND CONVENT. In 1877, the Sisters of the Humility of Mary moved to Ottumwa and with the help of Mary Talley established a hospital, naming it Talley Hospital in her honor. The hospital remained in this location at 424 North Court Street until 1914, when it moved into the old convent and school on Fourth Street and became known as St. Joseph Hospital.

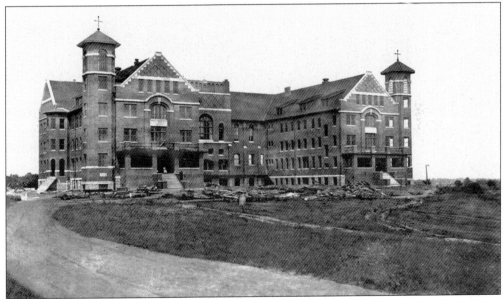

ST. JOSEPH ACADEMY AND CONVENT. In 1890, the Sisters of the Humility of Mary established St. Joseph Academy, a resident and day school for girls. In 1907, they purchased 125 acres north of the city, and the cornerstone for the school and motherhouse was laid in 1911. In 1925, St. Joseph's Junior College was established at the site, and in 1930, the name was changed to Ottumwa Heights College.

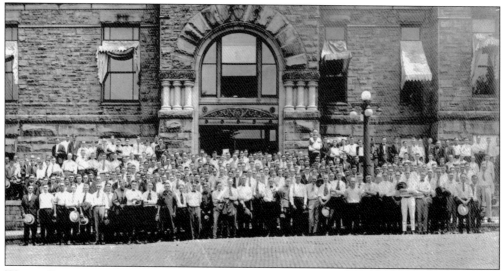

WORLD WAR I. A large group of inductees poses in front of the courthouse on July 22, 1918, on their way to training for service in Europe during World War I. Although large numbers of Ottumwa men served their country overseas and behind the lines, those left at home also played a role by buying Liberty Bonds and Red Cross fund subscriptions.

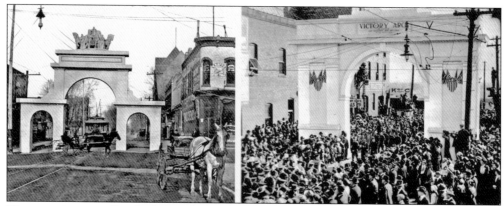

VICTORY ARCHES. On the left is the Victory Arch built on West Second Street near Court Street after the Spanish-American War. Note the streetcar, buggies, and dirt street. The peaked roof of the YMCA appears in the upper right. The photograph on the right shows the May 1919 celebration of the return of Ottumwa's Company G, with a new Victory Arch located near the site of the earlier arch.

Four

INDUSTRIAL HEYDAY
1922–1947

Ottumwa's general development and prosperity peaked during these years, despite the Great Depression. Unlike many other cities, Ottumwa continued to grow during the 1930s, partly because its major employer, Morrell, produced food products, which saw increased demand during the Depression. In 1930, Ottumwa's population reached 28,075, an increase of 22 percent from 1920. World War II provided an additional boost to Ottumwa's economy and, by 1950, despite the ravages of severe floods in 1944 and 1947, the city's population would reach 33,631. In both 1940 and 1950, Ottumwa was the eighth largest city in Iowa.

Much of this growth was due to the expansion of the Morrell and John Deere plants. At the end of World War I, Morrell employed around 1,200. By the mid-1930s, employment reached approximately 2,300. In 1951, 3,450 people worked for Morrell in Ottumwa. Morrell was one of the largest industrial employers in the state by the end of the 1940s, with only Waterloo's John Deere works and Rath packing plant employing more. Before World War II, Deere employed fewer than 500, but by 1951, its work force tripled. Both plants were unionized and provided workers with steadily rising wages and benefits.

The once flourishing cigar-making industry declined in the 1920s and essentially disappeared by the 1940s. The decline in the state's coal-mining industry, begun in the mid-1920s, meant that several employers in Ottumwa had to adjust to new markets. Railroads remained important; the Milwaukee and CB&Q Railroads together employed about 500. Ottumwa's next largest employers were Northwestern Bell Telephone, Lowenberg Bakery, and Johnston Lawn Mower. The city's infrastructure expanded with the construction of a new high school, St. Joseph hospital, YMCA and YWCA buildings, municipal swimming pool and golf course, hydroelectric dam and power plant, coliseum-armory, Jefferson Street Viaduct, Schaefer Stadium, airport, and naval air station. Richard Nixon was one of the more notable servicemen stationed in Ottumwa during World War II.

The floods of 1944 and 1947 wreaked havoc on the economy but paved the way for controlling the Des Moines River through construction of new upstream reservoirs and river straightening projects.

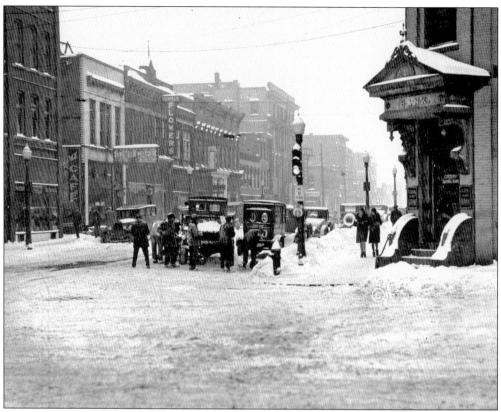

DOWNTOWN, 1920S. A snowstorm snarls traffic on Second Street, looking west from Market Street, sometime during the 1920s. The ornate Citizens Savings Bank entrance is visible on the right, with the Hofmann Building, Ottumwa Café, and Frasier Hotel on the left. Note that traffic lights and streetlights have been installed.

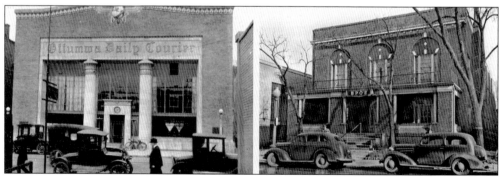

COURIER, ELKS CLUB. The *Ottumwa Daily Courier* was first published in 1848. In 1921, after operating in various locations around town, this Egyptian-influenced building on East Second Street was erected (left). The newspaper employed about 70 people by the end of the 1940s. The Elks Club (right) was located on East Second Street, next to the Courier building, one of dozens of fraternal and service organizations in the city.

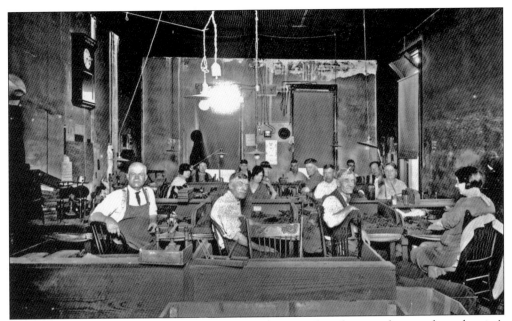

POTTER BROTHERS CIGAR FACTORY, 1924. At the time this photograph was taken, the city's cigar-making industry was nearly gone. George Potter began his career by selling cigars for D. A. Morey in 1884. In 1899, he started McKee and Potter. After this firm disbanded in 1917, he started Potter Brothers, located at 134 West Second Street.

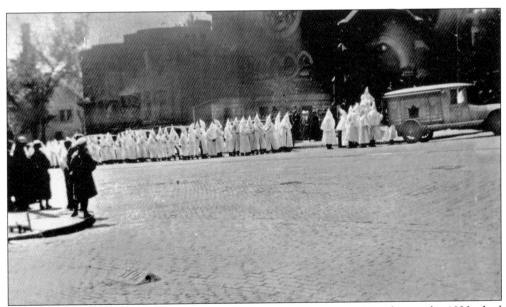

KU KLUX KLAN FUNERAL PARADE, 1924. Ottumwa, like many cities during the 1920s, had a KKK following. Known for their opposition to the political and cultural growth of Catholic, Jewish, and African American groups, the KKK had a powerful fraternal following among white Protestants throughout the Midwest. This photograph shows a KKK funeral march passing in front of the First Baptist Church at Fifth and Court Streets.

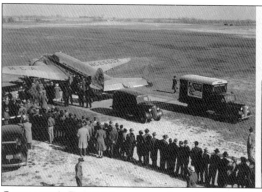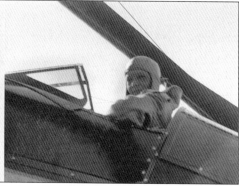

OTTUMWA'S FIRST MUNICIPAL AIRPORT. Established in the 1920s on North Court Road, where the National Guard Armory is presently located, the municipal airport grew throughout this period. The bottom photograph from about 1940 shows North Court Road on the left and Memorial Lawn Cemetery at the top. On November 1, 1940, the first Mid-Continent Airlines plane landed at the airport (above, left), establishing regular passenger service. Amelia Earhart (above, right) stopped there on May 31, 1931, flying an autogyro, which was a combination of airplane and early helicopter. She also visited Ottumwa in 1937, flying the Lockheed Electra that carried her on her ill-fated around-the-world flight.

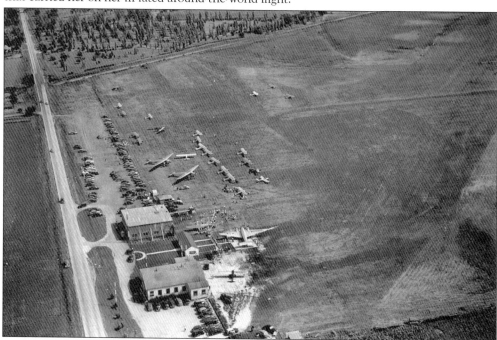

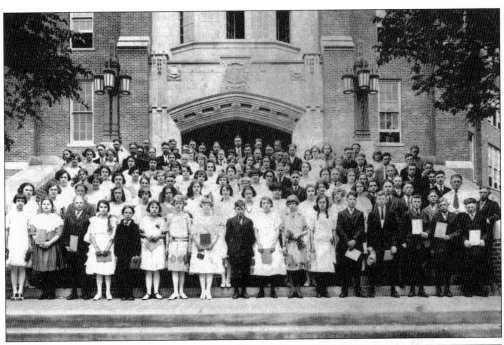

OTTUMWA HIGH SCHOOL.
As the city's population grew, the school district continued to add buildings to cover new and expanding neighborhoods. In 1923, a new million-dollar high school was erected on the site of Ottumwa's original brick school off Second Street between Union and College Streets. The Adams building was moved to the east in order to leave the site free. The former high school on West Fourth Street later became Washington Junior High. The photograph at top shows the 1923 graduating class of rural eighth-grade students posed on the steps of the new school, where they would begin high school classes the following year. The photograph at bottom shows the Ottumwa High School bicycle parking lot in 1938.

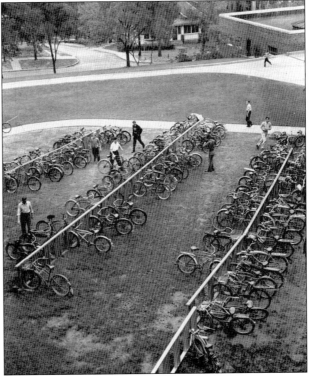

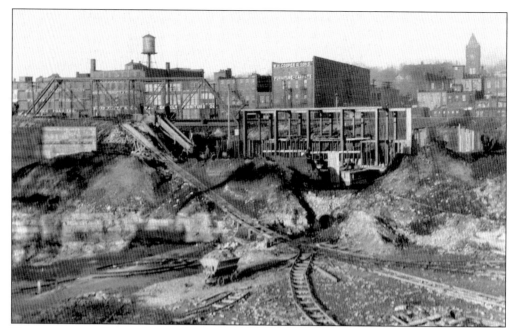

HYDROELECTRIC POWER PLANT CONSTRUCTION. The river provided a water supply for the city, and water wheels in the race generated electrical power to operate the municipal waterworks. Excess power was sold to commercial customers as well as powering the city's streetcars. In the late 1920s, the race was drained so a new dam could be constructed. This photograph shows the dry race bed and the framework of the hydro's main building.

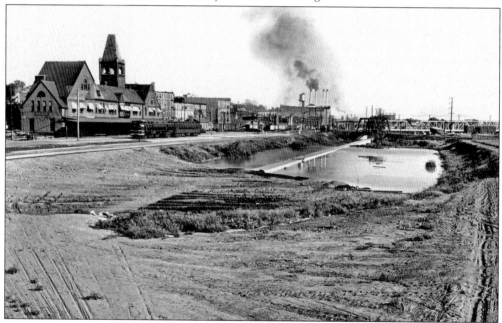

UNION DEPOT AND WATERFRONT. This view looking east in 1937 shows the city water intake coffer and sewer in the race. The hydroelectric dam is to the right, with the main building barely visible. Note the passenger train with one car by Union Depot, and the smokestacks of the coal-fired Iowa Southern Utilities power generation station at the top center of the photograph.

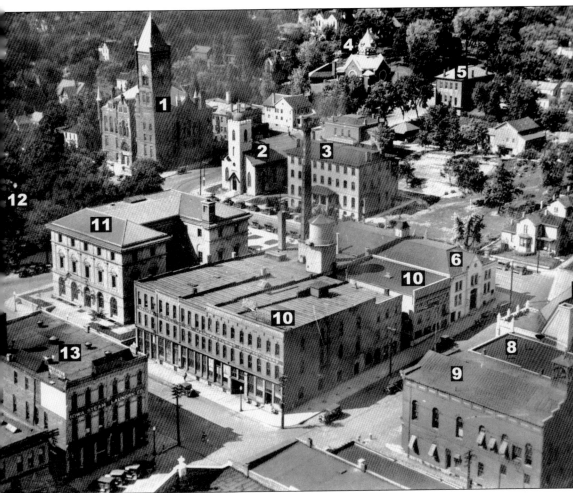

DOWNTOWN FROM THE AIR, 1928. This aerial view looks north with the intersection of Market and Third Streets at the center bottom. Numbers indicate (1) Wapello County Courthouse; (2) St. Mary of the Visitation Catholic Church; (3) St. Mary's High School, which had been St. Joseph Hospital; (4) First Baptist Church, built in 1904; (5) Sacred Heart Catholic School, (6) the armory; (7) First Methodist Church; (8) main fire station; (9) city hall and police station; and (10) Hall Candy Company, organized in 1880. Although in early years the company produced extracts and baking powder, Walter T. Hall soon began concentrating his business in candy, including hand-dipped chocolates, which were sold throughout the world. Additional numbers indicate (11) the Federal Building, (12) Central Park, and (13) Iowa Steam Laundry. Of the marked buildings, only First Baptist, First Methodist, and the courthouse retain the same functions. The federal building is now city hall. The others have all been demolished.

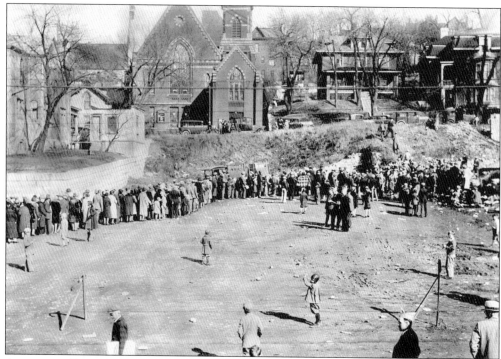

ARMISTICE DAY, 1929. After a parade through downtown, on November 11, 1929, the 11th anniversary of the end of the First World War, Ottumwans lined up for barbecue sandwiches in the vacant lot behind the Ottumwa City Hall. The First Congregational Church is across Fourth Street in the background, one of the few Ottumwa churches that did not occupy a corner lot.

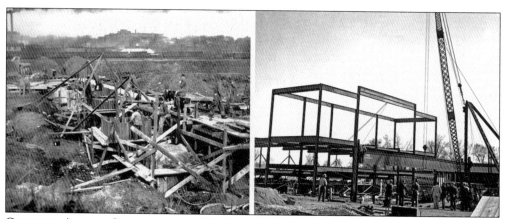

COLISEUM-ARMORY CONSTRUCTION. The Ottumwa Riverfront Commission guided construction of a new coliseum-armory just south of the river that cost $250,000 and was completed in 1934. The completed building hosted scores of cultural and community events until it was torn down in 2005. At left, crews hand-dig the footings. At right, steelworkers attach beams to the framework while dignitaries observe.

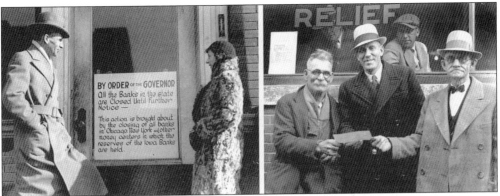

THE GREAT DEPRESSION. The economic depression of the 1930s created hardship for many families. The governor of Iowa ordered all banks in the state closed to prevent panic withdrawals. With the closing of larger banks, which held Iowa banks' reserve funds, local banks could not have met customer demands for large cash withdrawals. The first relief checks (right) were issued in 1933 to assist children and women who were in financial need.

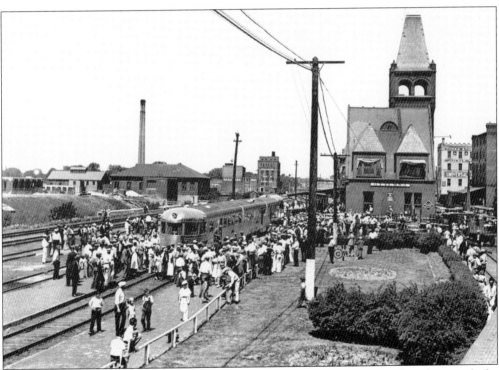

THE PIONEER ZEPHYR. Union Depot is crowded with Ottumwans gathered around the Burlington route's Pioneer Zephyr, an early diesel-powered, streamlined passenger train. After the Zephyr made a record run from Denver to Chicago in May 1934, attaining a top speed of 114.5 miles per hour, it made a slower return journey. This train is now on display at Chicago's Museum of Science and Industry. Ottumwa Water Works is on the left.

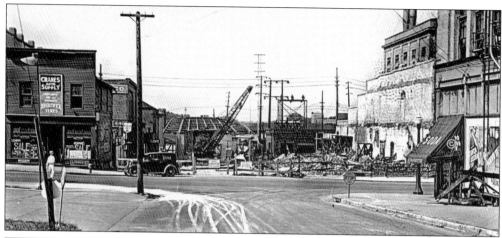

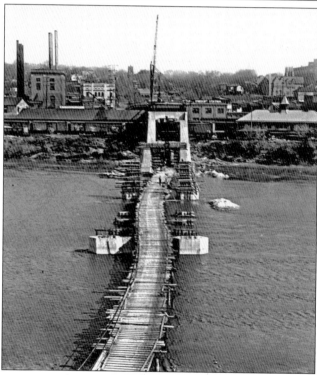

JEFFERSON STREET VIADUCT CONSTRUCTION. Construction started in 1935 on a new viaduct to carry Highway 34 over the Des Moines River in downtown Ottumwa. The photograph at top shows the construction from the corner of East Main and Jefferson Streets, with support for the bridge decking starting to take shape. The photograph at bottom shows the temporary construction bridge built of planks, with the Iowa Southern Utilities power plant on the left and the high school, completed in 1923, in the right background. To the right of the new construction, closer to the river, is the Rock Island Railroad Depot. The opera house is visible between the power plant and the new bridge.

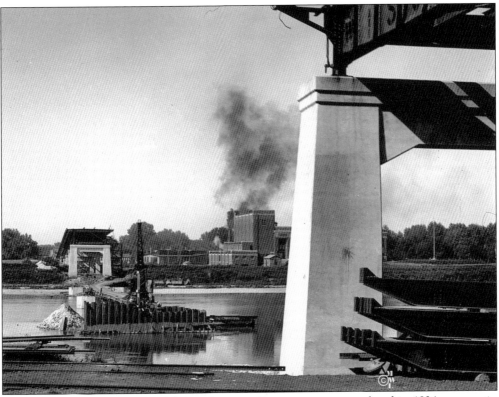

JEFFERSON STREET VIADUCT. The city's new coliseum-armory, completed in 1934, appears in the center background of the top photograph between the piers of the new Jefferson Street viaduct, as construction continues on the piers mid-river. Smoke from behind the coliseum is probably rising from the Johnston Lawn Mower plant. The bridge was completed and dedicated in 1936. The bottom photograph shows the crowd assembled for the dedication ceremonies. The coliseum is visible at the extreme left.

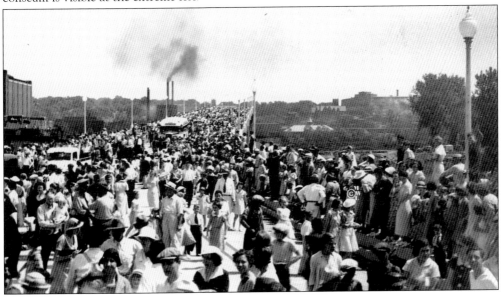

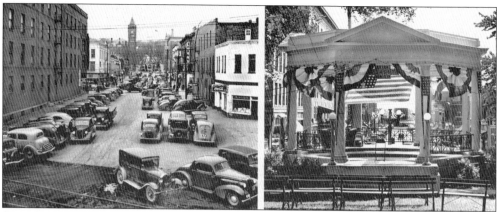

COURT STREET AND BANDSTAND. The view on the left, from the 1940s, was taken from approximately the same spot on the CB&Q railroad tracks as the photographs on page 11 and page 28. Note the courthouse tower in the background. On the right is Central Park bandstand decorated for a patriotic holiday in 1939, looking toward the south down Court Street.

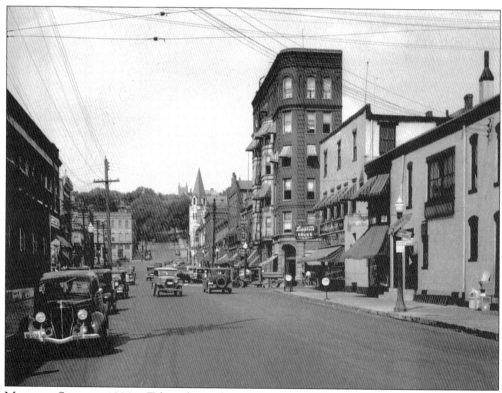

MARKET STREET, 1930s. Taken from about Commercial Street, this photograph looks up Market Street past Main toward Second Streets. The six-story building at Market and Main Streets is the Professional Building, the first steel-framed multi-storied building constructed west of the Mississippi River. The building was not commercially successful, partly because the narrow structure had very small offices and rooms, and it was torn down in 1962.

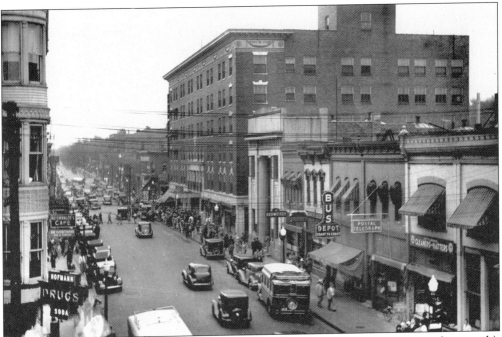

HOTEL OTTUMWA. Hotel Ottumwa dominates this view of Second Street (above photograph), looking west from Market Street to Court Street in about 1936. Built in 1917 at the corner of East Main and North Court Streets, the hotel included a restaurant named the Pink Pig, where water was served from pig-shaped pitchers (below, right). The original lobby (below, left) was open to the mezzanine floor, as shown in this view from about 1950. The hotel closed in about 1975, then was purchased by the Jim Schwartz family in 1982 and renamed the Parkview Plaza because of its location just off Central Park. The name was changed back to Hotel Ottumwa in 2005.

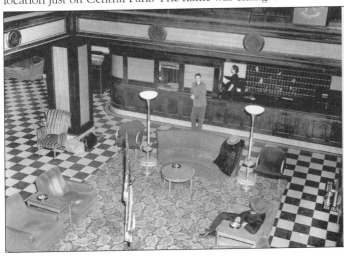

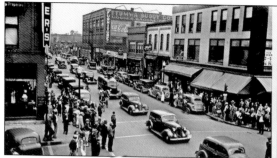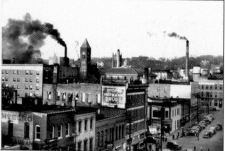

DOWNTOWN VIEWS. Even during the Great Depression, Ottumwa's central business district was busy, especially on Morrell's paydays. Downtown businesses stayed open late on Morrell's payday for many years, as in the 1936 view (left) of Main Street looking west from Court toward Washington Streets. On the right, a high-level view of the downtown area clearly shows smokestacks and clouds of coal smoke.

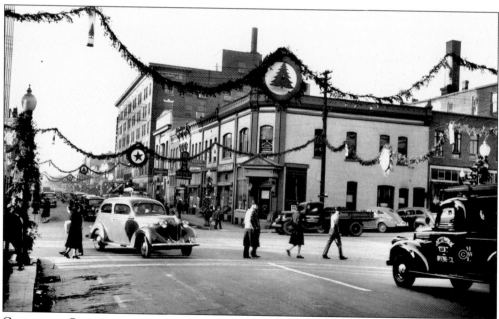

CHRISTMAS SHOPPERS, 1941. This view from the corner of Second and Market Streets shows the Christmas decorations of the era. Hotel Ottumwa is in the background and Citizens Savings Bank is at the center of the photograph.

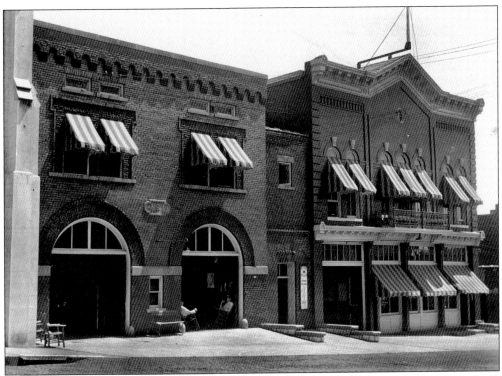

CITY HALL AND FIRE. The top photograph shows the central fire station (left) and city hall, on Market Street near Third Street, in 1931. Note the firemen lounging in the doorway. Police department headquarters was located on the main floor of city hall, with city offices above. The city hall building was gutted by fire on November 16, 1940 (below, left). The building was rebuilt after the fire with much less ornamentation, as shown in this view from 1953 (below, right). Both buildings were removed in the 1960s, when city offices moved to the federal building and a new central fire station was built at Fourth and Wapello Streets.

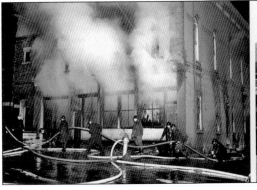 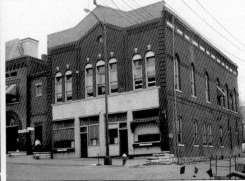

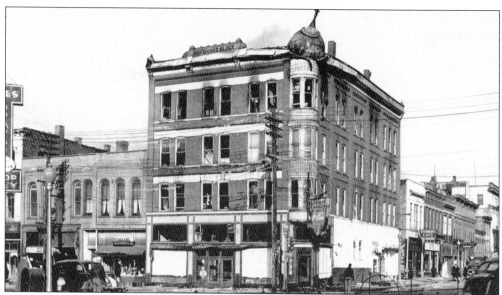

HOFMANN BUILDING FIRE. This photograph shows the destruction caused by the March 24, 1940, fire, which caused $200,000 in damage and sent three Ottumwa firefighters to the hospital. The fire was thought to have started in a basement storeroom at the base of the elevator, and spread rapidly up the elevator shaft to all four floors. Firemen stretched more than 5,000 feet of hose while fighting the Easter Sunday–morning fire.

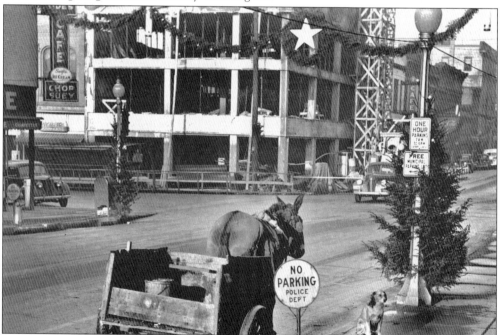

NEW HOFMANN BUILDING. By the following Christmas season, a new six-story Hofmann Building was under construction (background). The new building housed Hofmann Drug, complete with soda fountain, on the main floor, with a bookstore in the basement and offices for rent on the upper floors. Note the donkey cart with canine guard in the no-parking zone in the foreground. Kide's Café is on the corner to the left.

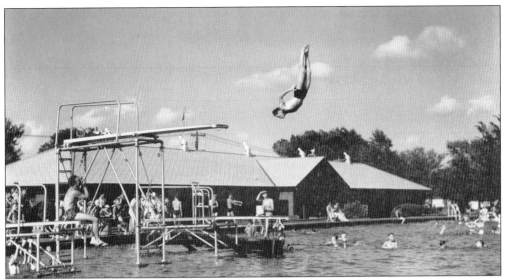

MUNICIPAL SWIMMING POOL. Located on Ottumwa's south side at Milner and Keota Streets, the pool was built in 1929 and was reportedly the most expensive and largest municipal pool in the state at the time. This photograph shows enthusiastic swimmers in 1937. The pool operated until the early 1990s.

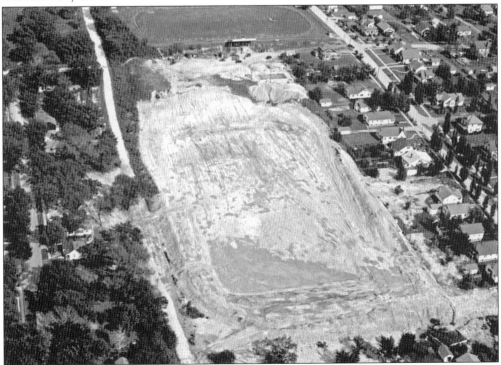

SCHAFER STADIUM CONSTRUCTION, 1941. Schafer Stadium, a WPA project, was named after Walter B. (Wally) Schafer, a 1913 Ottumwa High School graduate who won 12 varsity letters, played football at the University of Chicago, and was killed in action in World War I. The new stadium cost $90,000 and was dedicated on October 3, 1941. The old Ottumwa High School football field, at the top of the photograph, became a practice field.

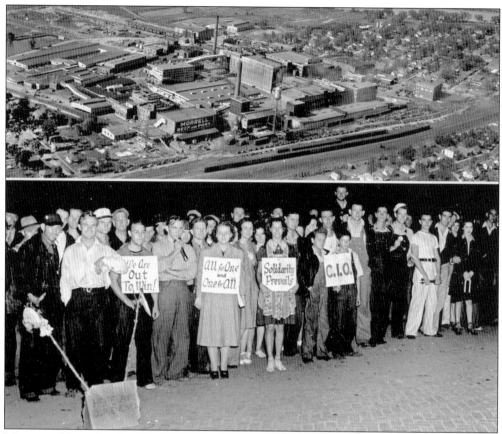

MORRELL MEATPACKING. Morrell became the country's fifth largest meatpacking company during this period. The top photograph shows the extensive plant layout from the air before 1945. During the 1930s, Morrell employees joined the labor union bandwagon. Strikes were part of this union-building process. The bottom photograph shows workers on strike in August 1939. The first four men on the left were strike leaders, including Charles Sears, local president, second from left.

MORRELL TRANSPORTATION. Because the plant consisted of more than 30 major buildings and several other smaller facilities by the 1940s, a variety of means were used to move meat and other materials between buildings. Note the two horse-drawn wagons in the photograph at left, taken in 1942. On the right is the plant gate, erected in 1927 to celebrate the company's centennial.

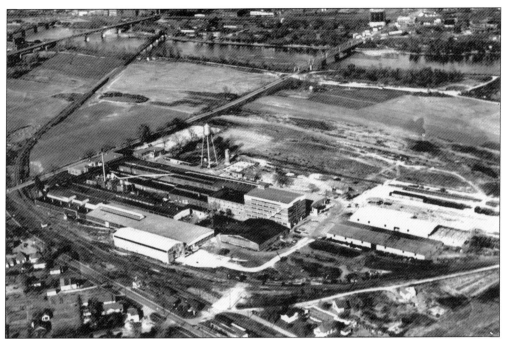

JOHN DEERE DAIN WORKS. During and immediately after World War II, the Dain plant, a major manufacturer of hay balers and other farm equipment, saw its employment jump tremendously. The top photograph shows the Dain plant from the air, looking toward the northeast and the Des Moines River. From the top left of the photograph are the Market Street Bridge, Jefferson Street Viaduct, railroad bridge, and Vine Street Bridge. During the war, Dain made artillery shells and other equipment for the military, as shown in the photograph below. Although John Deere bought the company in 1910, the Ottumwa plant used the Dain name until 1947.

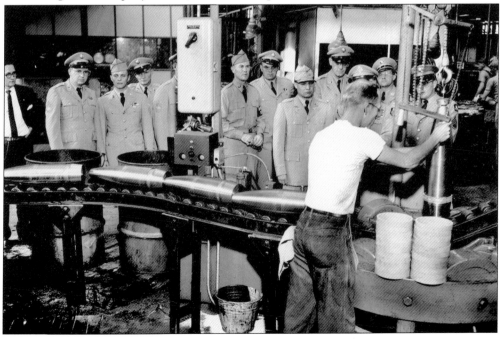

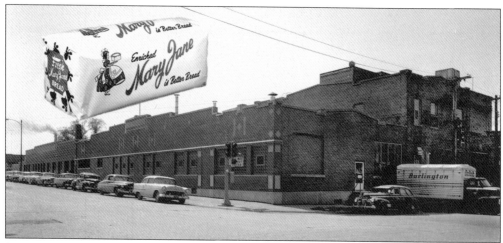

LOWENBERG BAKERY. Shortly before Anton Lowenberg's death at age 76 in 1923, he and his sons built a new plant, reportedly the largest bakery in Iowa at that time, at Wapello and Second Streets. The company's main brand during this period was Mary Jane Bread, as shown in the inserted photograph. Although this photograph is from a later period, the building's exterior was largely unchanged from the 1920s.

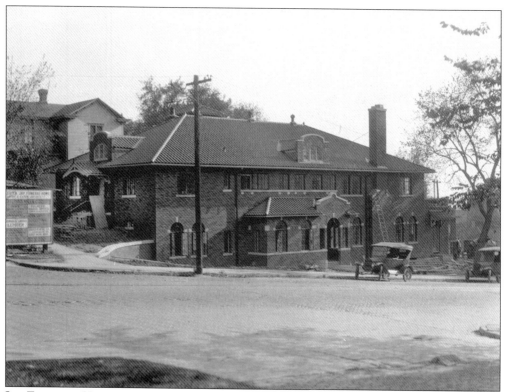

JAY FUNERAL HOME, 1939. Under construction when this photograph was taken, Jay Funeral Home, located on North Court Street, has been one of Ottumwa's long-standing funeral homes. This is thought to be the first funeral home in Iowa built for that purpose rather than being adapted from a house or other building.

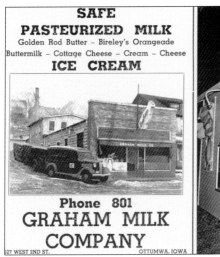

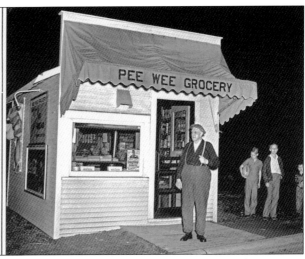

GRAHAM MILK AND PEE WEE GROCERY. Graham Milk Company (left) was started in 1916 by F. M. Graham. By the 1930s, it had moved to 627 West Second Street. This advertisement from 1937 shows the range of products. Pee Wee Grocery (right) was located on Ottumwa's northwest side at 519 East McLean Street in 1941. Although this was no doubt the smallest, there were dozens of small groceries in the city.

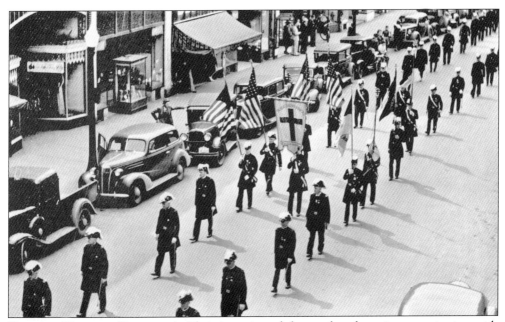

KNIGHTS TEMPLAR PARADE. A Christian-oriented fraternal and service organization with roots in 11th-century Europe, the Knights Templar evolved by the 19th century into a fraternal organization that was part of the Masons. This photograph shows a Knights Templar parade on Main Street in the 1940s. Note the Templar cross on the banner.

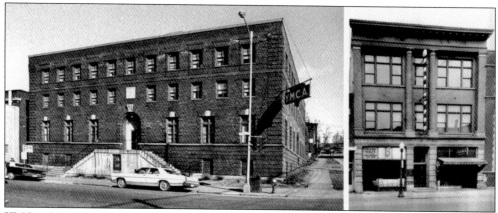

YMCA, MASONIC TEMPLE. In 1921, a new YMCA building (left) was constructed at the corner of Second and Green Streets. It was used until the 1970s. A new YWCA building opened in 1924 at Second and Washington Streets, replacing the old YMCA building. The Masonic Temple (right), pictured in 1947, was located at 110–112 West Second Street. Ottumwa's first Masonic lodge, No. 16, was chartered in 1848.

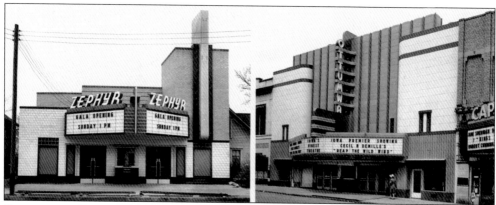

ZEPHYR AND OTTUMWA THEATERS. The Zephyr (left), seen here before its first showing, was built in 1941 on Church Street, opening soon after a fire had destroyed the Ottumwa Theater downtown. Admission for adults was 25¢, day or evening. The Ottumwa Theater was razed and rebuilt, opening in 1942 and advertising that it was an "absolutely fire-proof" theater (right). Reconstruction took about a year because of a wartime steel shortage.

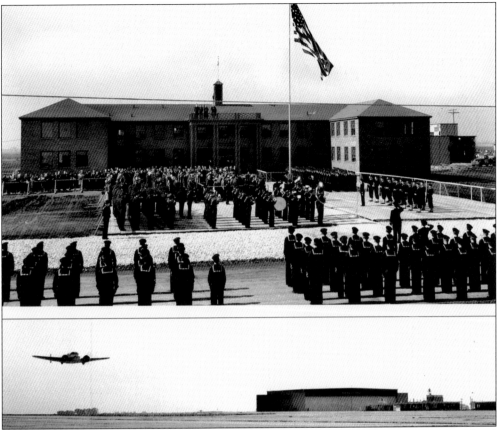

NAVAL AIR STATION. One of several navy pilot-training facilities in the United States, Naval Air Station Ottumwa employed 500 civilians and trained 6,656 cadets and officers with a total of 605,553 hours of flight time. Commissioned in March 1943 (above), the station officially closed on July 10, 1947. The lower photograph shows the last navy plane leaving the facility on October 2, 1947. The facility then became the Ottumwa municipal airport.

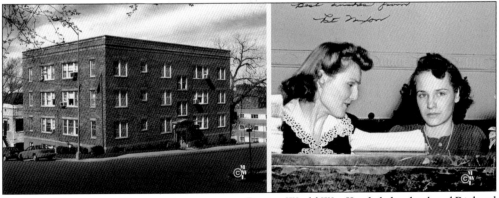

PATRICIA NIXON AND TISDALE APARTMENTS. During World War II, while her husband Richard Nixon was stationed at Naval Air Station Ottumwa, Pat Nixon worked at Union Bank and Trust in downtown Ottumwa. Pat Nixon (left) is seen with coworker Jean Shelby, in 1943. The future president and first lady lived in the Tisdale Apartments at Fourth and Green Streets (the photograph at left is from a later date).

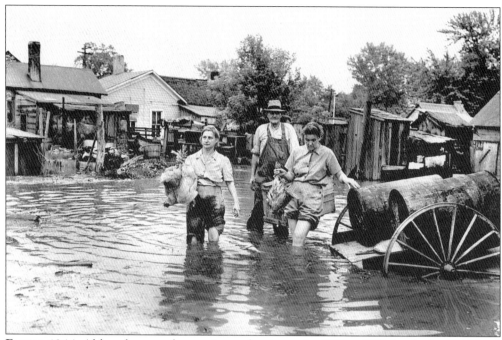

FLOOD, 1944. Although not as destructive to the city as the 1903 or 1947 floods, the 1944 flood crested at just over 20 feet and caused extensive damage. The woman on the left is carrying two hens by the feet, while the woman on the right is holding a rooster and the man is carrying a crate, as they evacuate. Note the outhouses at center right. The exact location is unknown.

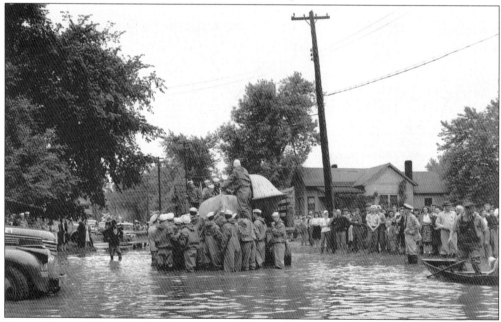

FLOOD RELIEF. When the floodwaters rose, flight training was suspended at Naval Air Station Ottumwa so sailors could be sent to assist with flood relief. Here a group of sailors unloads navy boats that have been trucked into the flooded area to evacuate residents. Note the U.S. Navy truck at left, its wheel half-submerged in floodwater. The exact location is unknown.

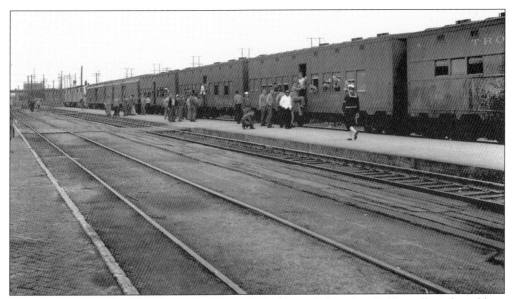

WORLD WAR II. A troop train pauses at Union Depot in September 1944 to allow the soldiers and sailors some exercise and a smoke break. Note the conductor at center, in white shirt, and the Shore Patrol member in full uniform walking toward the troops from the right. More than 4,000 Ottumwans—one in nine residents—served in the armed forces during the war, and 148 were killed.

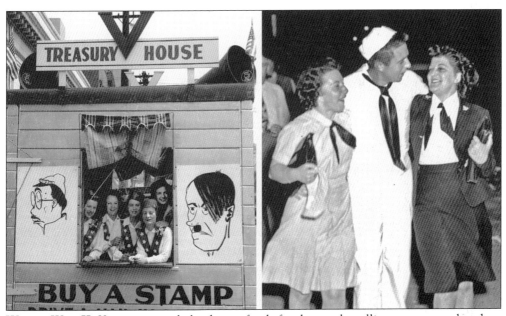

WORLD WAR II. Young women helped raise funds for the war by selling stamps at a booth at Market and Main Streets in 1942 (left). Rationing and citywide scrap drives also helped the war effort. With Japan's surrender in 1945, the war was over and three service-people celebrated on VJ Day (right).

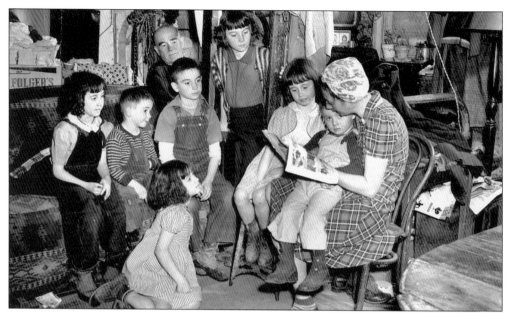

CENTRAL ADDITION, JANUARY 1947. Platted in about 1890, Central Addition was promoted as the garden spot of Ottumwa with lots for sale at $250 each, a considerable sum at the time. However, the neighborhood, bordered by the river, flooded in 1892 and frequently thereafter. By 1944, it was a working-class neighborhood accessed by bridges on Benton Street (below) and Wapello Street. Heavily damaged by floods in 1944 and 1945, the neighborhood was essentially destroyed by the 1947 flood. By the mid-1950s, the last residents had been relocated, and most of the area has been turned into city parks surrounded by lagoons, the remnants of the old river channel.

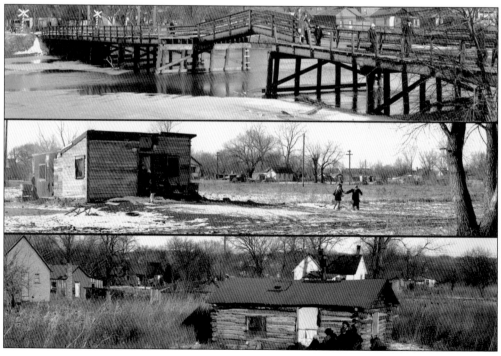

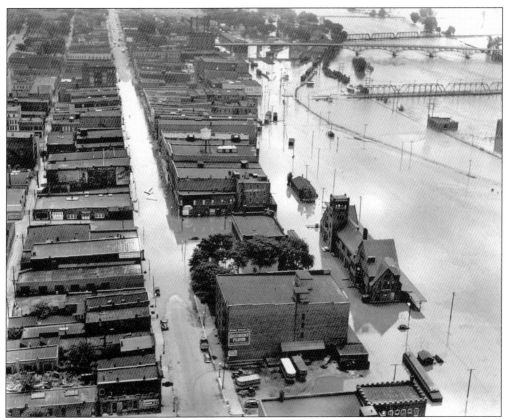

FLOODS, 1947. The Des Moines River inundated the city twice within a single week in June 1947, killing two and driving thousands from their homes. The river crested at 20.25 feet on June 7, short of the 1903 record but much more damaging because of a larger population and economic base. The aerial view at the top shows water surrounding Union Depot and extending down Main Street almost to Green Street, past the Professional Building, which is visible at top left. The flood invaded the Morrell plant, reaching the entrance gates (below, left), which were at the northern end of the plant, farthest from the river. It also flooded Vine Street all the way to the main entrance of the John Deere plant (below, right).

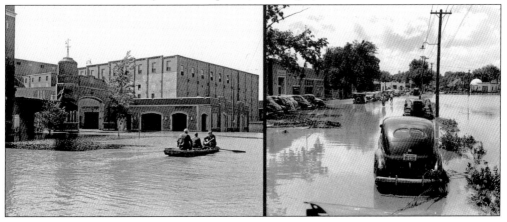

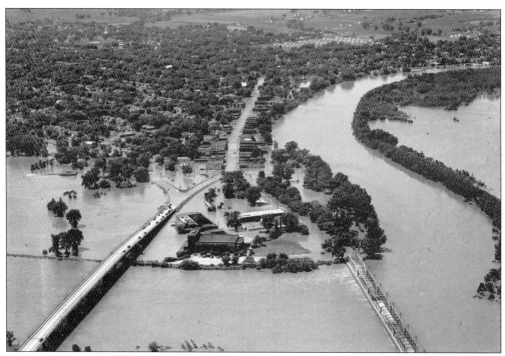

A SECOND FLOOD, 1947. After the water began to recede, a second flood one week later covered a third of the city's total area, and nearly 10,000 people had to be evacuated from their homes. Thirty thousand people were left without electricity and safe drinking water. The aerial view at the top, looking toward South Ottumwa, shows the Y-shaped southern end of the Jefferson Street Viaduct under water, with a flooded Church Street extending into the distance. The main river channel sweeps across the foreground of the photograph and up the right side. The Market Street Bridge is at lower right, and the coliseum is visible in the center at river's edge. Houses in Central Addition are surrounded by water (below, left). Some refugees were housed in a tent city erected on Golf Avenue on the city's north side (below, right).

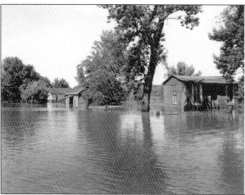
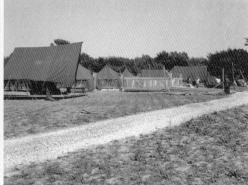

Five

INDUSTRIAL ZENITH
1948–1973

Ottumwa recovered from the devastating 1947 flood and went to work on widening and straightening the Des Moines River. However, economic problems during the latter half of this period led to population declines and a search for new employers. Ottumwa's longtime major employer, the Morrell meatpacking plant, remained quite large through the mid-1960s. However, because of labor-management strife, the rise of new competitors, and growing obsolescence of its Ottumwa facilities, the company began to shed workers. By 1970, the plant employed about half as many workers as it had 20 years earlier. The company modernized its Ottumwa plant extensively during the 1950s and 1960s, but closed on July 14, 1973.

Because so much of Ottumwa's economy was connected to Morrell, the loss of this one employer had serious repercussions. In 1960, about 18 percent of all of the city's jobs were in the food industry. In fact, jobs at Morrell, Deere, and the weakening railroad industry comprised about 30 percent of all the employment in Wapello County in that year. When Morrell and the railroads declined during the 1960s, the city's manufacturing sector was gutted. By 1970, Ottumwa's population had fallen for the first time since the city's founding in 1843, declining by 12.6 percent from its level in 1960 to just below 30,000. Although it had remained the state's eighth largest city in 1960, Ottumwa fell to twelfth place in 1970.

Still, during the post–World War II years, Ottumwa saw significant improvements in its riverfront and related infrastructure. During Mayor Herschel Loveless's two terms from 1949 to 1953, the groundwork was laid for river improvements, and street and sewage improvements were made. River widening and straightening as well as construction of flood walls and levees started in the mid-1950s. The state's construction of the Red Rock and Saylorville Dams helped to control upstream floodwaters, and the extensive engineering projects would pay enormous dividends when the Des Moines River flooded again during the summer of 1993.

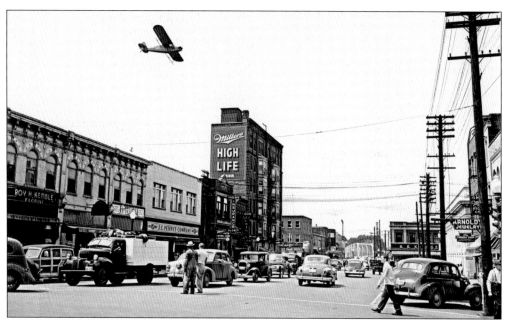

SPRAYING FOR MOSQUITOES. An airplane flying at low level sprays DDT over the downtown to combat mosquitoes in June 1948. This view looks southwest along Market Street toward the river, with the six-story Professional Building in the center, JCPenney along the left, and Arnold's Jewelry and the Camera Shop on the right. Until DDT was banned in the 1960s, it was commonly used to keep mosquito populations under control.

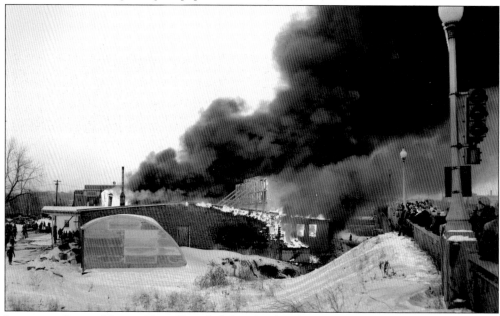

JOHNSTON LAWN MOWER FIRE. Founded shortly after the beginning of the 20th century, the company made curtain stretchers and sash pulleys before starting to manufacture all-steel lawn mowers made with pressed steel gears, patented by Allen Johnston, in 1914. Just before this February 1949 fire, the plant employed 135 people. The building was located at the south end of the Jefferson Street Viaduct, next to the coliseum.

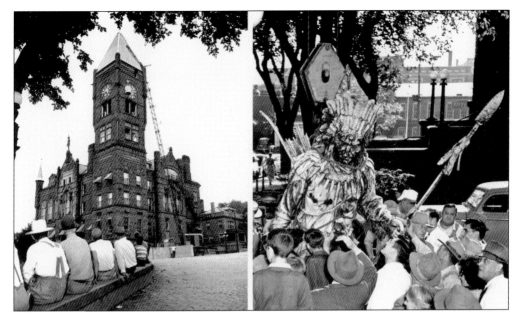

COURTHOUSE TOWER REMOVED. In the early 1950s, the tower, chimneys and ornamentation—about 450 tons of stone, brick, and bracing—were removed from the Wapello County Courthouse. Most of this work was undertaken due to concerns about the tower's maintenance and gave the building a more streamlined, modern appearance. The statue of Chief Wapello was removed for maintenance and then replaced.

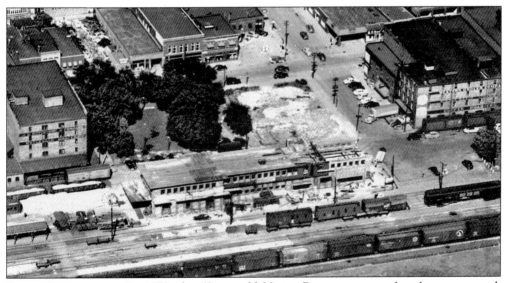

DEPOT REMODELING. In 1950, the 60-year-old Union Depot was gutted and reconstructed, the tower and peaked roof removed, and marble floors and stone facade added. The work is underway in this aerial photograph from August 1950, with the new roof mostly in place and a new addition under construction on the southeast end of the building.

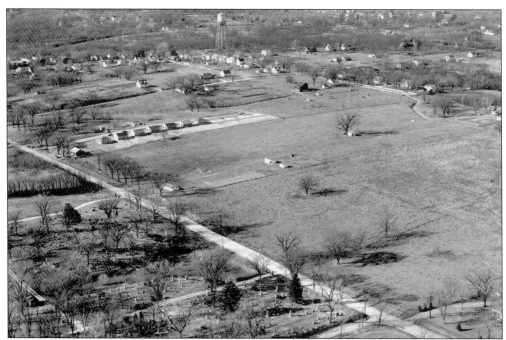

OTTUMWA HOSPITAL SITE. This view looks northwest over the site of the new Ottumwa Hospital on the city's northeast side in May 1950, right before the groundbreaking. Pennsylvania Avenue runs diagonally from left to right, with the Memorial Park water tower at center top. Calvary Cemetery is at the bottom left.

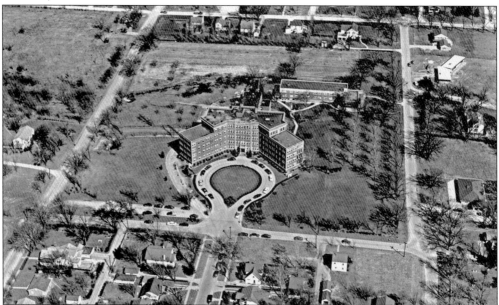

ST JOSEPH HOSPITAL. The city's Catholic hospital, run by the Sisters of the Humility of Mary, was built on Alta Vista Avenue in 1926. A new entrance, emergency room, and surgical wing were added in 1959, just after this photograph was taken. The nurses' residence is visible above the hospital in this view, looking east. The hospital closed in the 1980s and was sold to Ottumwa Regional Health Center.

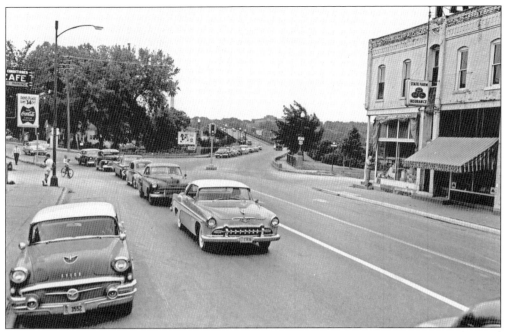

CHURCH STREET, 1950s. Traffic moves along Church Street, with the right side of the road leading to the Jefferson Street Viaduct and the left side leading to the Market Street Bridge. At the middle right side of the photograph is a former city park where Highway 34 now crosses. Fareway grocery store is located where the buildings are.

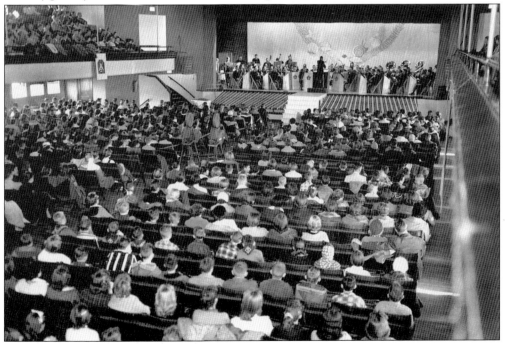

COLISEUM INTERIOR. A large crowd attends a U.S. Army band concert in 1958. The event was filmed for *The Big Picture*, a show for network television that promoted the armed services. The coliseum hosted a multitude of concerts and other events for many years.

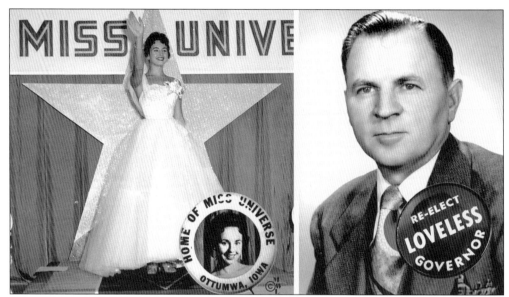

WELL-KNOWN OTTUMWANS. Carol Morris (left) visited Evans Junior High after she won the 1956 Miss U.S.A. and Miss Universe pageants. Her father, Rev. LaVerne Morris, was pastor of Davis Street Christian Church. Herschel Loveless (right) was elected Iowa governor in 1956. He was emergency director during the 1947 flood and later mayor. As governor, he spearheaded efforts to build the Red Rock and Saylorville Dam flood-control projects on the Des Moines River.

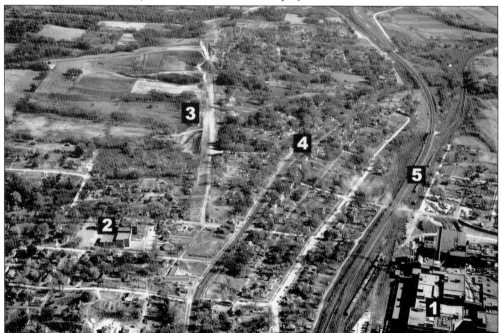

HIGHWAY 34. This aerial view shows the east end in October 1953 as work began on a four-lane highway from Ottumwa to Agency. In addition, a new Highway 34 loop was built around the east side of the city and across the lagoon area. Numbers indicate (1) the Morrell plant, (2) old and new Franklin Schools, (3) highway construction, (4) old highway on East Main Street, and (5) the Burlington Railroad.

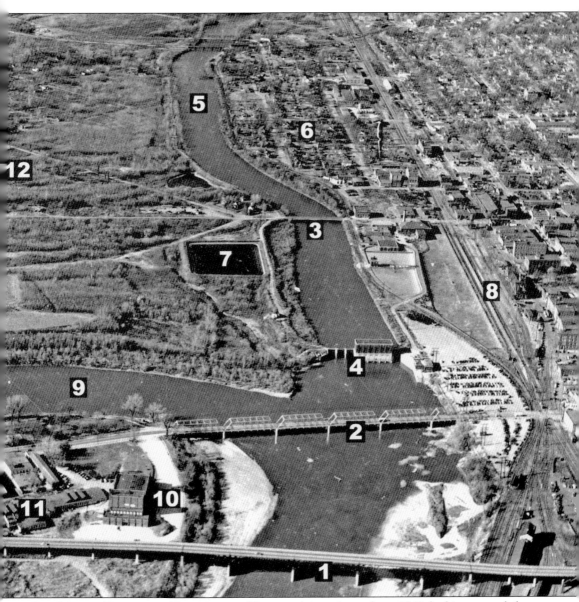

DES MOINES RIVER AND DOWNTOWN. This aerial view from about 1949, looking toward the northwest, shows the river's channels and downtown before the massive river-straightening project began. The city's bridges are (1) Jefferson Street Viaduct, (2) old Market Street Bridge, and (3) old Wapello Street Bridge. The small hydroelectric dam (4) is just above the Market Street Bridge. The narrow channel (5) west of the Wapello Street Bridge would be widened later in the decade to become the main channel. The area marked (6) is the future Marina Gateway industrial district, before redevelopment started. The square area in the center (7) is a settling basin for the city's water supply, eliminated when the channel was widened. The 1950 remodeling of Union Depot (8) has not yet started. The looping main channel (9) would become the city's lagoons after the straightening. At lower left are the coliseum (10) and Johnston Lawn Mower (11). Although Central Addition was essentially abandoned after the 1947 flood, some houses remain (12).

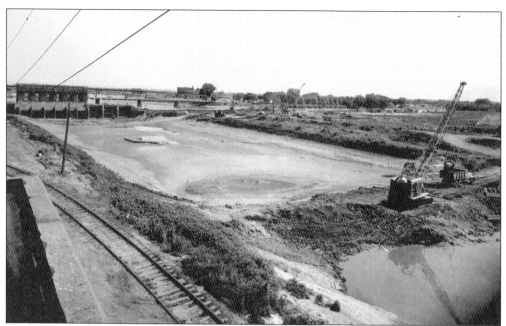

RIVER STRAIGHTENING. Although the 1947 flood was the most destructive in the city's history, high water recurred in following years, keeping flood control at the top of the city's priority list. An extensive project begun in the mid-1950s widened the secondary channel, which had been used for electrical power generation, while blocking off the meandering main channel. In the top photograph, work proceeds on a temporary earthen dam across the new channel upstream from the hydroelectric dam, built to dry the channel so a wider permanent dam could be constructed. The lower photograph, taken from South Ottumwa, shows the hydroelectric dam under construction. An earthen dam at extreme right, just downstream from the new construction, helps to keep the channel dry.

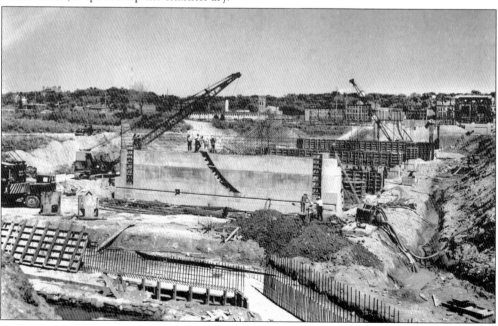

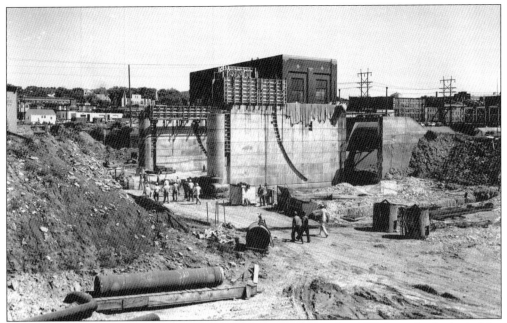

NEW HYDROELECTRIC DAM. This photograph, taken in September 1959 from the dry bed of the new channel, shows the enormous scale of the piers, which support the gates of the hydroelectric dam. Note the crew of workmen crossing the riverbed. The curving indentations in the piers support the swing of the gates to control the passage of river water.

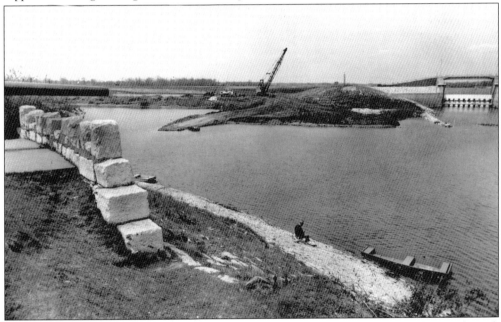

OLD CHANNEL CLOSED. After the new dam was completed and the channel opened, work shifted to closing off the meandering main channel, which had slowed water movement and encouraged flooding. Although the channel was largely blocked off by levees to become lagoons in the new city park, water flows slowly through the old channel, keeping the lagoons from becoming stagnant. The park occupies the area previously known as Central Addition.

OTTUMWA MUNICIPAL AIRPORT, 1957. After Naval Air Station Ottumwa was closed in 1947, the city took over the runways, tower, and buildings for use as the municipal airport. This view taken from the tower shows a number of remaining navy-era buildings. Many were rented or purchased by local businesses as the airport became an industrial park. One became a roller-skating rink, and a drive-in theater was added.

WALSH HIGH SCHOOL. From 1954 to 1960, the Catholic high school for boys was located in the former Wormhoudt house at 402 Chester Avenue (left). In 1960, the school became coed, with classes held at the airport complex until a new building (right) was completed in 1962 on the city's north side. The school closed in 1970 and was used by the Ottumwa School District as Walsh Junior High.

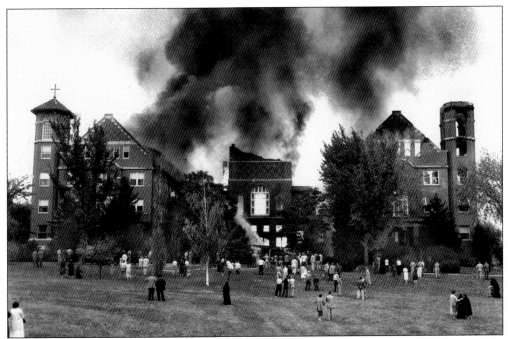

OTTUMWA HEIGHTS FIRE. On October 8, 1957, the building housing Ottumwa Heights College and Academy and the motherhouse of the Sisters of Humility of Mary was destroyed by fire. With the nearest hydrants at North Court Street, firefighters were slowed by having to lay hoses for blocks. Classes were moved to the municipal airport until new buildings were constructed. The reconstruction resulted in significant expansion of the college.

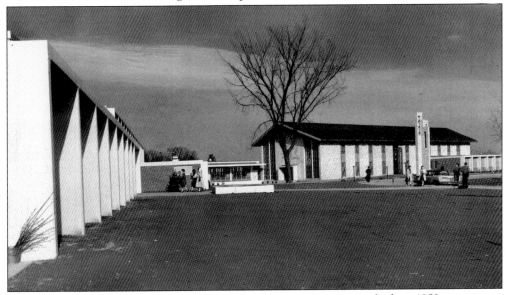

NEW OTTUMWA HEIGHTS. The cornerstone of a new campus was laid in 1958, just a year after the devastating fire, and the first buildings opened in 1960. This view from 1961 shows a classroom building to the left and the chapel to the right. In 1967, the college admitted male students for the first time. Although it was a Catholic college, by 1970 more than half of the students were Protestant.

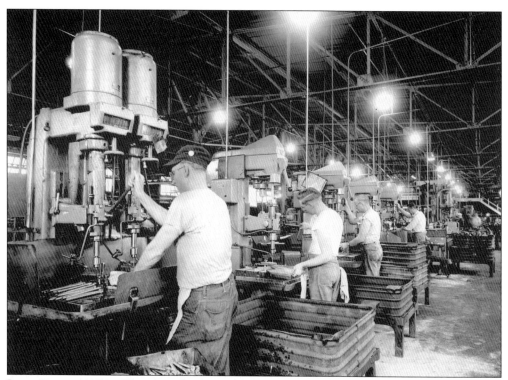

JOHN DEERE, 1950S. The plant firmly established itself as Ottumwa's second-largest employer during the early post–World War II years. The top photograph shows workers operating drill presses. The lower photograph shows workers leaving the plant and crossing Vine Street to the parking lot at the end of their shift, sometime in the 1950s. The plant specialized in hay-making equipment and later built equipment for large-scale lawn-care operations such as golf courses.

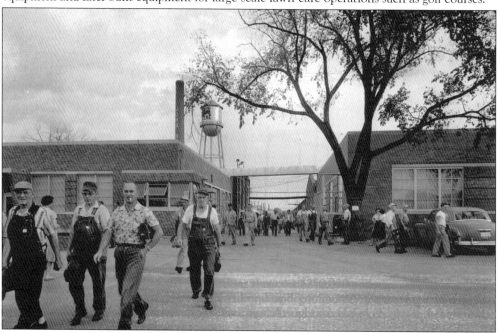

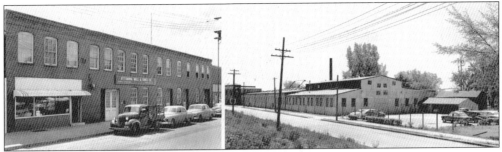

SMALL MANUFACTURING. During the 1950s and 1960s most of Ottumwa's manufacturing consisted of small workplaces of 25 to 50 employees, such as Ottumwa Mill and Construction Company on West Main (left), which produced a wide variety of millwork. Ottumwa Shipping Container at 1224 West Second Street (right) manufactured corrugated boxes used primarily by John Morrell and Company. It was one of several local businesses that depended on Morrell.

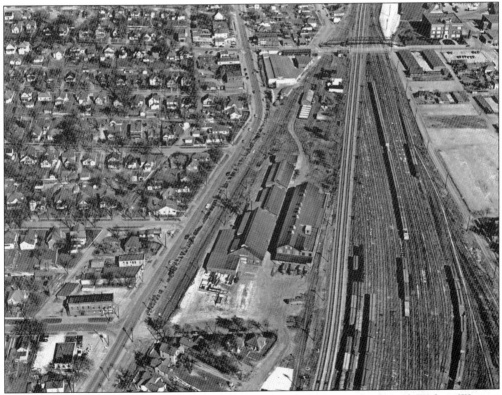

WINGER MANUFACTURING. Incorporated in 1939 by Barney, Lloyd, and Walter Winger, Winger Manufacturing, at center of photograph, engaged in light steel fabrication, particularly meatpacking equipment such as hand trucks, tables, conveyors, and containers. The complex, located at 1200 East Main Street, was destroyed by fire in January 1956. Note the extent of the railroad yards to the right of the photograph and Morrell's main administration building at top right.

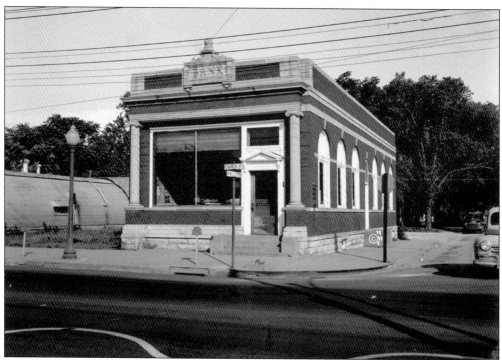

SOUTH OTTUMWA SAVINGS BANK. South Ottumwa Savings Bank, chartered in 1910, had offices on Church Street. After a much larger bank was built alongside this structure in 1964, where the tin building is in this photograph, the old building was torn down. Eventually a new addition was built on the site. South Ottumwa Bank first expanded to the north side with a branch at Pennsylvania and Elm Streets in the 1970s.

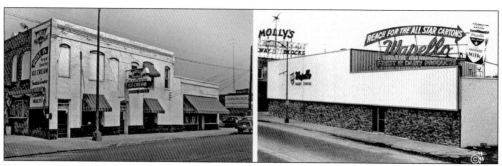

WAPELLO DAIRIES. One of the larger dairies in the city, Wapello Dairies purchased milk from local farmers and delivered to both homes and stores. The left photograph shows the company's old plant on Church Street in 1953. The right was taken in 1967 after a plant expansion and facade modernization.

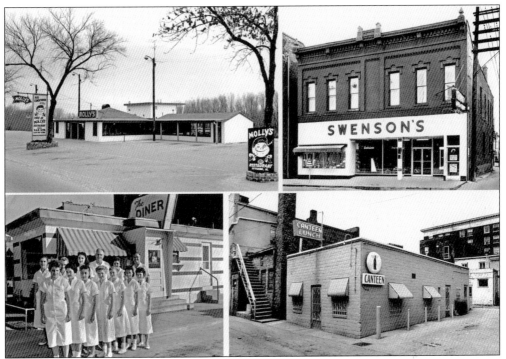

RESTAURANTS. Molly's Restaurant was located on Richmond Avenue. Swenson's Bakery on South Court Street was a popular source for doughnuts and rolls. The Diner, shown in 1959 with owner Jerry Wood and employees, was located at Third and Washington. Displaced by construction of the YWCA pool, the building was moved just across the street. Canteen Lunch in the Alley opened in the 1930s and still serves loose-meat sandwiches.

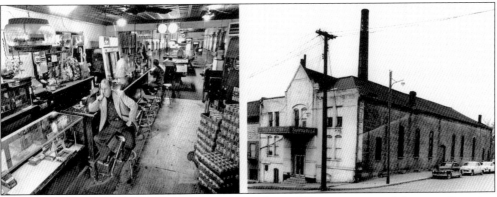

ENTERTAINMENT. Mission Billiard Parlor on East Second Street was a men's hangout featuring a bar along with billiard and pool tables. This picture was taken on the final day of operation before the building was removed as part of the downtown urban renewal project. The Shangri-la Youth Center was at Market and Fourth Streets in the building that was previously the armory. The building was removed and the site is now a parking lot.

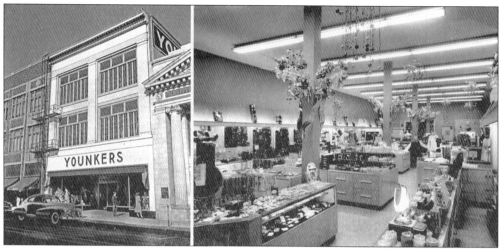

DOWNTOWN RETAIL. Through the 1960s, Ottumwa's downtown had many prosperous retail establishments. Younkers department store (above, left) was located on East Main Street next to the First National Bank. The interior views (above, right), taken sometime in the 1950s, show the jewelry and cosmetics departments. The lower photograph shows Maddens department store, on East Second Street, in the center. The Hofmann Building is at the left of the photograph. Other downtown retail businesses in the period included S. S. Kresge, Woolworth, JCPenney, J. B. Sax, Brody's Store for Men, Brody's Store for Women, Sears, Libson Shops, Spurgeons, Diana Shops, and Bookin Jewelry.

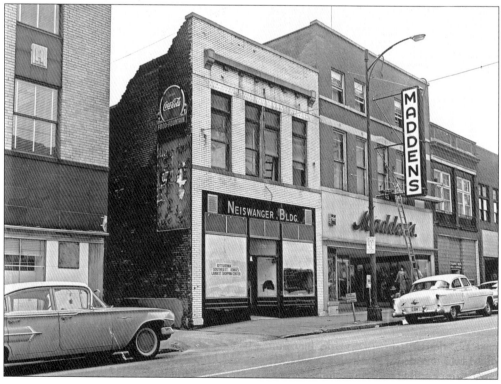

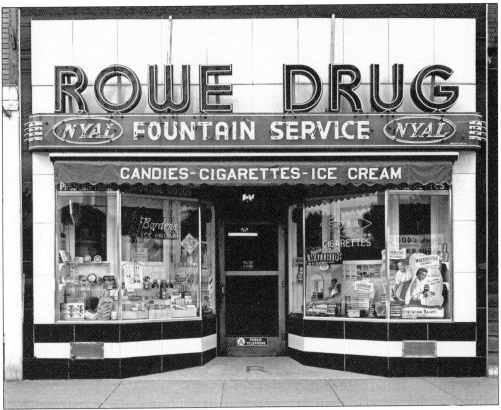

ROWE DRUG. One of South Ottumwa's more popular drug stores, Rowe Drug was located on Church Street. This view in May 1950 shows off the art deco facade. Rowe Drug had one of the oldest soda fountains in the city. At one time it was also one of the most elaborate, with a marble counter and marble pillars on the back bar.

WARD DRUG. Located at the corner of Second and Court Streets, Ward Drug, like many of the city's small pharmacies, also offered a soda fountain serving sandwiches and ice-cream treats. This photograph was taken in 1959.

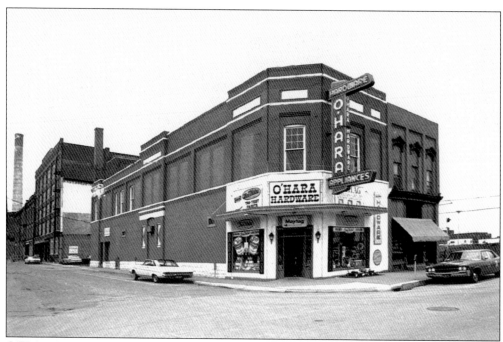

O'HARA HARDWARE. Located at Market and Commercial Streets, O'Hara Hardware was started by Martin O'Hara in about 1940. An urban renewal project removed the building in the early 1970s, and the business moved to 500 West Main Street in Marina Gateway. The interior view (below, left) is from the 1960s. At right below, Martin O'Hara watches and takes photographs as the building comes down.

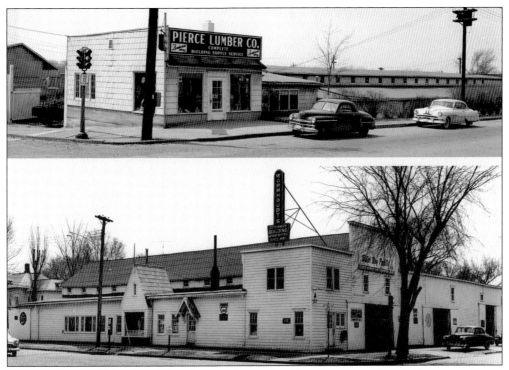

LUMBER YARDS. Wormhoudt Lumber was located at Five Corners in South Ottumwa. Pierce Lumber was at Iowa Avenue and Main Street in the city's east end.

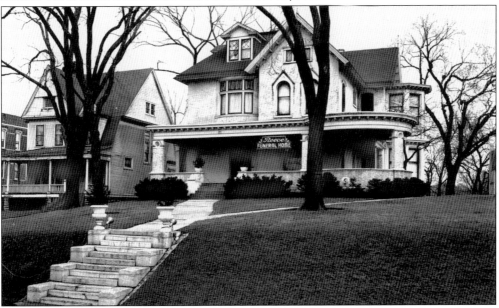

REECE FUNERAL HOME, 1954. Charles Blake of First National Bank built the most expensive house in Ottumwa at 607 East Second Street in 1860 at a cost of $2,000. Joseph Dain purchased the house when he moved his farm equipment business to Ottumwa, and remodeled extensively. Carroll and Marie Reece bought it in 1939 for use as a funeral home, and the Reece family made many additions and improvements in the late 1990s.

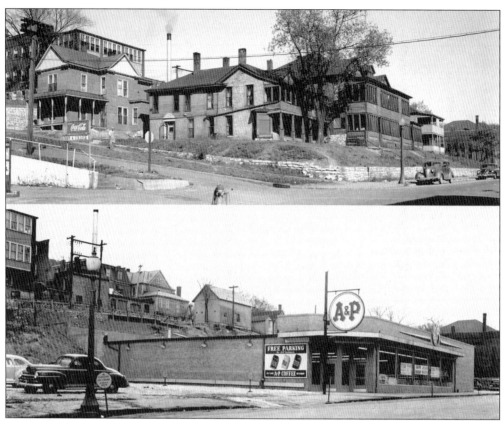

A&P Supermarket. A&P was one of the first supermarket grocery chains in the United States. The photograph at top shows the 500 block of East Main Street before houses were removed and the hill dug out to construct the market. B'nai Jacob Synagogue, built in 1915, is at the far right in both photographs.

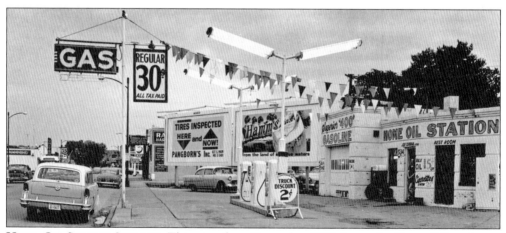

Home Oil Service Station. This view from November 1958 shows the Home Oil station at 534 Church Street, one of the more popular places for south side residents to fill up with gas during the postwar years—in this case, at 30.9¢ per gallon. Owner Joe Curran is standing in the doorway.

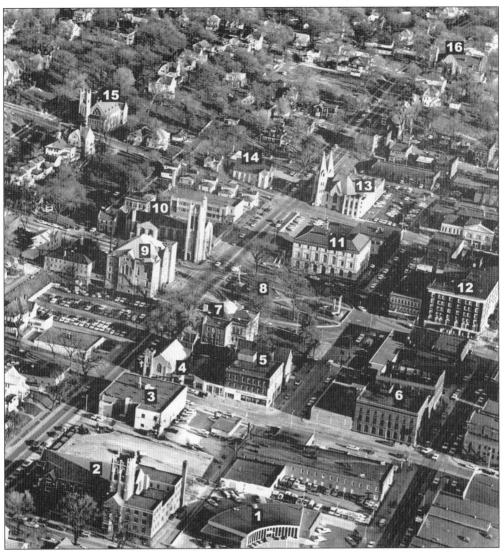

DOWNTOWN, 1967. This aerial view looks east from about Marion Street across the downtown area. Numbers mark (1) First National Bank; (2) First Presbyterian Church; (3) American Telephone and Telegraph; (4) the Salvation Army Citadel; (5) Ottumwa Carpet Center and Knights of Columbus hall; (6) YWCA; (7) Ottumwa Public Library; (8) Central Park; (9) Wapello County Courthouse; (10) St. Mary of the Visitation Catholic Church, convent and school; (11) city hall; (12) Hotel Ottumwa; (13) First United Methodist Church; (14) First Church of Christ Scientist; (15) Trinity Episcopal Church; and (16) First Lutheran Church. Ottumwa Carpet Center and the Knights of Columbus hall were destroyed by fire in 1982 and a new Knights of Columbus hall was built on the site. First Church of Christ Scientist was torn down in the early 1970s and replaced with a drive-in bank. Other buildings remain, though some have new owners or new titles.

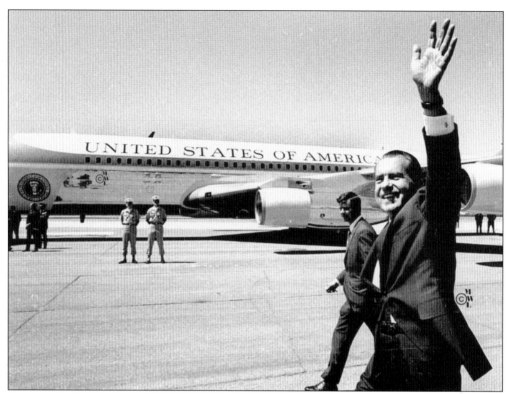

NIXON IN OTTUMWA. Richard Nixon was stationed at Naval Air Station Ottumwa during World War II, and returned to the city in 1971, when he was president of the United States, to dedicate Rathbun Dam in Appanoose County. This photograph was taken at Ottumwa Municipal Airport as the president was about to board a helicopter for the flight to Rathbun. *Air Force One* is in the background.

IOWA TECHNICAL EDUCATION CENTER. One of Iowa's regional community colleges, this center opened in 1966 at the municipal airport, using buildings left from the Naval Air Station era. After merging with Centerville Community College, it became Indian Hills Community College in 1970. Iowa congressman Neal Smith speaks to a crowd of 1,000 at a graduation ceremony in August 1972, held on the college's airport campus.

MORRELL STRIKE. In April 1948, the United Packinghouse Workers of America, CIO, called a nationwide strike in an attempt to raise wages and secure the 100,000-member union's power within the industry, including at Ottumwa's Morrell plant. The strike lasted more than two months, with several arrests and considerable violence occurring in Ottumwa. This view shows picketers being kept off railroad property by police.

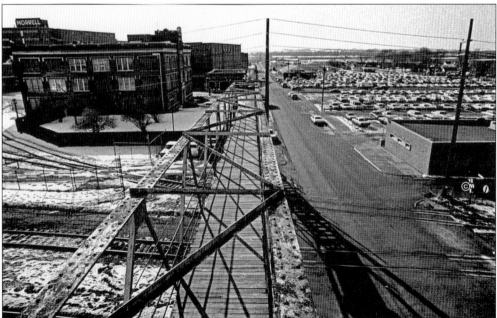

MORRELL PEDESTRIAN OVERPASS. This photograph was taken from a girder atop a pedestrian overpass above the railroad tracks just north of the Morrell plant in 1972, just one year before the plant closed. The administration building is to the left and the credit union building to the right. The overpass allowed workers to avoid delays caused by train traffic.

MORRELL PLANT CLOSING. Although this photograph of a solitary employee standing in front of the plant was taken during a closing scare in 1970, the newspaper headline suggests the devastating impact that Morrell's closing on July 14, 1973, had on the city for years to come.

THE LAST DAY. This July 1973 calendar was left lying on a lunchroom table in one of the Morrell workers' break rooms on closing day, July 14, 1973.

Six

RENEWAL
1974–2006

Ottumwa's recovery since the Morrell plant's closing in 1973 has been long and difficult. The city's population continued to recede for 20 years after Morrell left town. Between 1970 and 1980, Ottumwa's population fell to 27,381, a loss of eight percent. After the severe farm depression years of the 1980s, Ottumwa's population slipped another 12 percent to settle at 24,488 in 1990. However, since 1990, Ottumwa's population has stabilized; from 1990 to 2004, the city's population inched up to 24,680.

The effects of the Morrell closing continued to linger. Ten years after Morrell's closing, no employer had yet emerged to replace the plant's former significance. The John Deere works employed 1,400 workers in 1984. Hormel, another meatpacking firm that built a new plant in Ottumwa in 1974 in the shadow of the former Morrell buildings, employed 850, followed by Everco Industries (an automobile parts plant) with 460, Ottumwa Hospital with 420, and St. Joseph Hospital with 285.

During the mid-1980s, Ottumwa suffered another devastating blow when the Hormel plant's workers went out on strike in support of their fellow strikers' efforts at the company's flagship facility in Austin, Minnesota. Hormel reacted by firing hundreds of workers and by December 1986, the company indicated it would stop slaughtering at the plant. Although city officials bargained with Hormel, the plant closed on August 22, 1987. However, Excel Corporation, a Cargill subsidiary, bought the former Hormel facility and quickly began to build up a new workforce. Although its workers are not paid as well as their counterparts during the Morrell and Hormel eras, Cargill Meat Solutions, as the Excel chain has been renamed, has continued to grow and now employs about 2,000.

Since the 1990s, Ottumwa has added a new multi-purpose swimming facility called the Beach. Indian Hills Community College has continued to expand. A new shopping area on Ottumwa's west side has blossomed. Construction of a new events center, replacing the Depression-era coliseum, is underway. In addition, construction continues on a four-lane bypass around the east and north sides of Ottumwa, completing a new highway corridor stretching from Burlington to Des Moines.

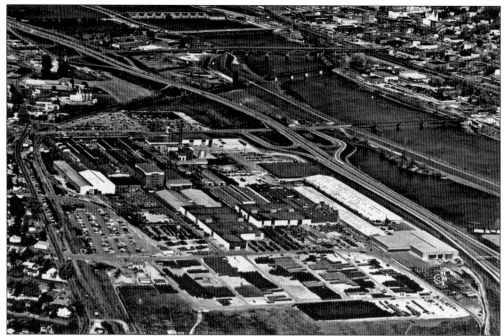

JOHN DEERE OTTUMWA WORKS. After the Morrell plants closed in 1973, the Deere plant became the city's major employer. The plant has produced a variety of John Deere equipment throughout the century since Joseph Dain founded it, including hay baling machines and products for commercial lawn care. This aerial view from 1978 looks toward the north with the river and Highway 34 in the background.

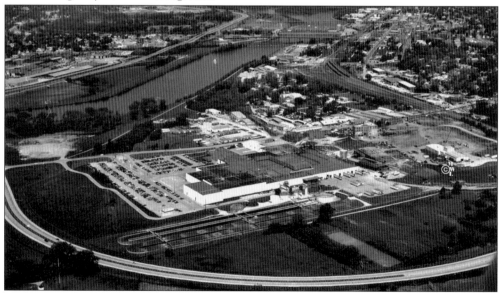

EXCEL CORPORATION MEATPACKING PLANT. In 1987, Excel bought Hormel's facility just south of the former Morrell plant. Most of the Morrell buildings have been removed by this time. Now called Cargill Meat Solutions, the plant is the largest employer in the city. Highway 34 circles east and south of the Excel plant, visible at the bottom of the photograph. John Deere Ottumwa Works is to the left, across the river.

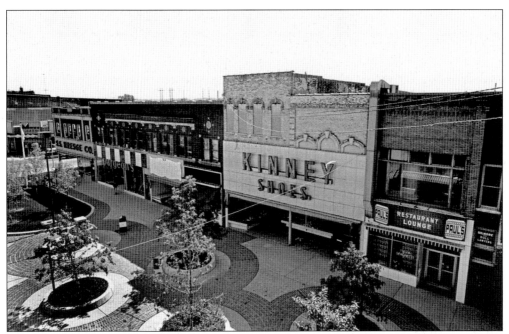

DOWNTOWN PEDESTRIAN MALL. In an attempt to bolster downtown business during the 1970s, and following a trend in downtown renovations in other cities, city authorities closed off several blocks of downtown streets for a pedestrian mall. This view shows East Main Street from Court to Market Streets before several buildings were removed to construct the Wapello Building. The pedestrian mall was removed and traffic patterns restored a few years later.

PEDESTRIAN MALL SCULPTURE. The L-shaped pedestrian mall extended from Third Street down Court Street and then east on Main Street. This view shows the Herbert Ferber sculpture in place at Main and Court Streets. Hotel Ottumwa (Parkview Plaza) is in the right background, People's Savings and Loan is in the left background. Ferber was a relative of Edna Ferber, novelist, who lived in Ottumwa as a young girl and hated the city.

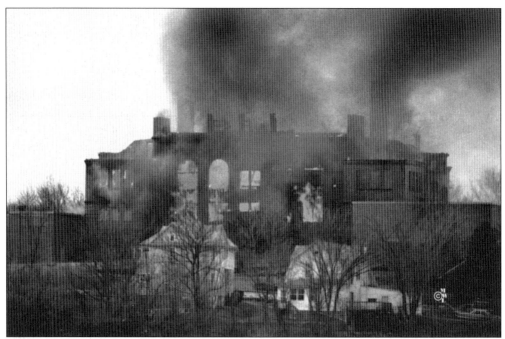

WASHINGTON JUNIOR HIGH FIRE. After the city's three junior high schools were consolidated into Evans Middle School, Washington Junior High School was left empty. Built in 1899 as the city's high school, it burned in a spectacular arson fire in 1990. The wings, which had been added later, remained and were used as the Ottumwa Christian School for a number of years.

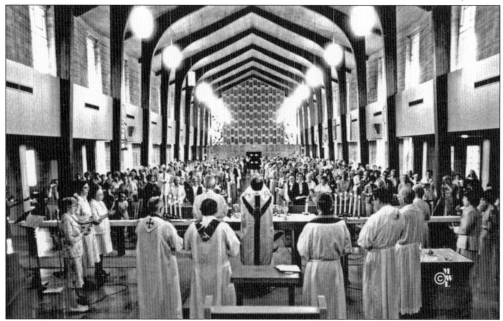

LAST MASS AT OTTUMWA HEIGHTS. Ottumwa Heights College held its last graduation ceremonies in 1979. This view from 1982 shows the last Mass held at the chapel for the Sisters of the Humility of Mary who had operated the Catholic junior college since 1925. The property was sold to the state of Iowa and became the main campus of Indian Hills Community College.

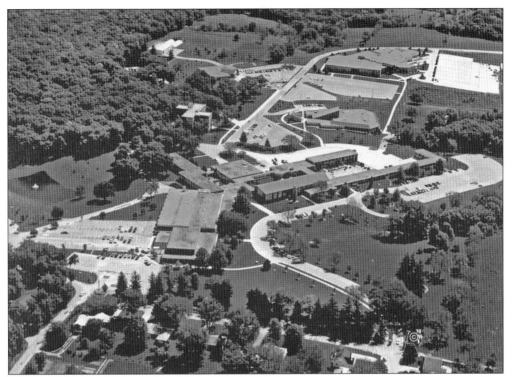

INDIAN HILLS COMMUNITY COLLEGE, 1993. After its opening in 1970, the community college grew rapidly, buying the campus of Ottumwa Heights College in 1981. The college offers associate degrees in both liberal arts and technical fields, including avionics, robotics, health occupations, criminal justice, and computer forensics. During the 1990s, Buena Vista University, based in Storm Lake, began offering IHCC students the option of finishing four-year degrees at the Ottumwa campus.

INDIAN HILLS NEW CONSTRUCTION. Since 1993, a number of new buildings have been added to the campus, including Oak Hall Dormitory (left) and the Rosenman Video Conferencing Center (right). Both are located at the eastern end of the campus, sites that appear at the top of the aerial photograph above.

QUINCY PLACE MALL. Construction of this new shopping mall on Ottumwa's west edge just off Highway 34 began in the late 1980s. This view shows the mall in 1993, just as development around the area was beginning. Today much of Ottumwa's commercial activity is centered at the shopping mall and the growing commercial district nearby, making Ottumwa once again a destination for retail shopping.

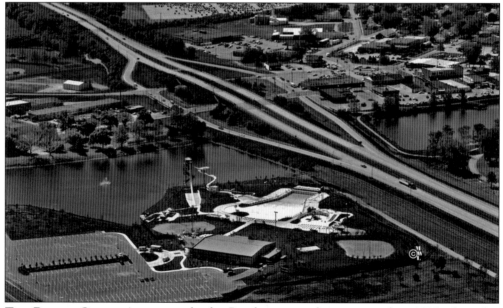

THE BEACH. Ottumwa's water park, the Beach, was newly constructed in 1993 when this photograph was taken looking south. Two of the Ottumwa Park lagoons are visible, marking the site of the old river channel. Highway 34 cuts across the photograph, showing the interchange that leads to Church Street to the right and Market Street to the left.

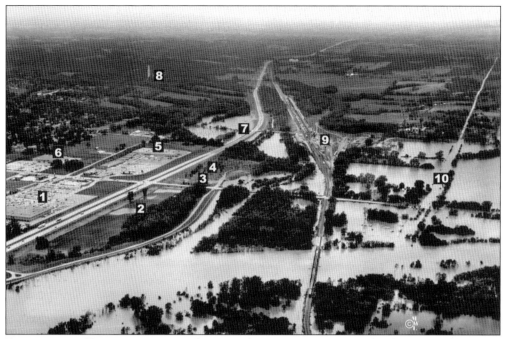

FLOOD, 1993. Heavy rains triggered yet another Des Moines River flood in 1993. The aerial view at top shows the extent of the flood near Highway 34 and Quincy Avenue. Numbers indicate (1) Quincy Place Mall, (2) site of Ottumwa 8 Theatre, (3) site of Applebee's restaurant, (4) site of Vaughn Motors, (5) K-Mart, (6) Hy-Vee supermarket, (7) Wildwood Drive, (8) site of Wal-Mart and Menards, (9) railroad yards, and (10) Blackhawk Road. The photograph below shows emergency levees being built to protect the city's waterworks, which was running at full capacity to supply the 250,000 residents of Des Moines who were left without water when their waterworks flooded. The Wapello Street Bridge is at right. Although outlying city neighborhoods suffered damage from the high water, the downtown area was spared because of river improvements made since the 1950s.

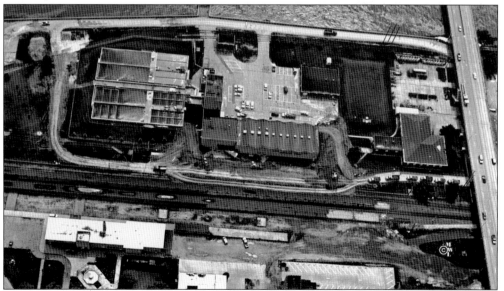

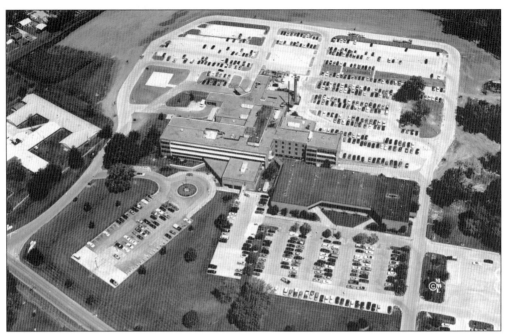

HOSPITAL AND CLINIC. This view from 1993 shows Ottumwa Regional Health Center at the left and Ottumwa Clinic (dark roof) at right. The medical community is one of the larger employers in the area. Ottumwa Regional Health Center's affiliation with University of Iowa Hospitals and Clinics brings specialists in many fields to the community to hold regular office hours. Both the health center and clinic have been expanded since this photograph was taken.

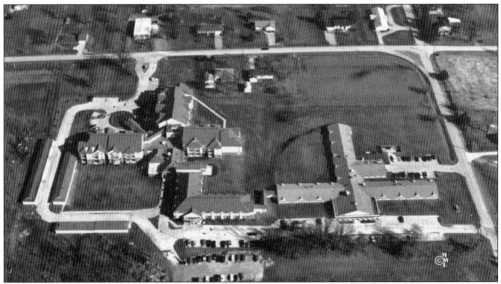

PENNSYLVANIA PLACE. Ottumwa's aging population requires facilities for retirement living and elder care. This 1998 view shows early development of the Pennsylvania Place retirement community east of the health center. The complex at lower right is Vista Woods Care Center. At the lower left is Sylvan Woods assisted living facility. The complex above is for senior independent living. Pennsylvania Avenue runs along the right and Bladensburg Road across the top.

WAL-MART SUPERCENTER. With the opening of Wal-Mart on Highway 34 west of the city, Ottumwa's commercial district stretched west from Quincy Place Mall. This photograph was taken in February 2003, just before the store's opening.

OTTUMWA 8 THEATRE. This new development replaced the aging downtown theaters with an eight-screen first run theater, located across Highway 34 from Quincy Place Mall, in the former Central Addition.

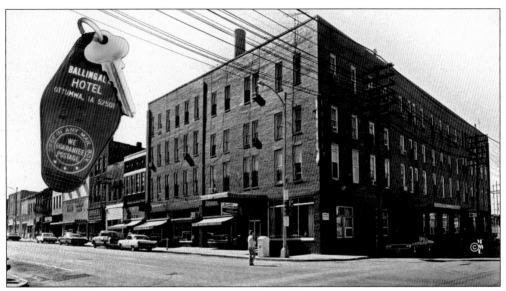

BALLINGALL HOTEL. Through the years, the Ballingall Hotel underwent many renovations and changes. One of the Midwest's premier hotels when it was built in the 1860s, by the 1960s it was used mostly by transient workers. In the 1970s and again in the 1990s, attempts were made to renovate the building to its former glory, but in 1996, the building was demolished.

HOTEL DEVELOPMENT. Fairfield Inn is one of a cluster of new national-chain hotels along Highway 63 on Ottumwa's north edge. Americinn is located on West Second Street, on the former site of the Vaughn Motors complex.

WAPELLO COUNTY LAW ENFORCEMENT CENTER. Built along West Second Street on the former site of Lowenberg Bakery, which closed in the 1980s, the law center replaced the antiquated county jail, which had been built in 1906, and provided up-to-date space for both the county sheriff's office and the Ottumwa Police Department. This photograph was taken in May 2006.

OTTUMWA HIGH SCHOOL. After more than 80 years of service, Ottumwa High School remains the center of secondary education in the city. A vocational-technical center was built alongside the main building in the 1970s, shortly after this photograph (left) was taken, and many improvements have been made through the years. The front steps, which have deteriorated, are to be replaced. The fish-eye view at right shows the work starting.

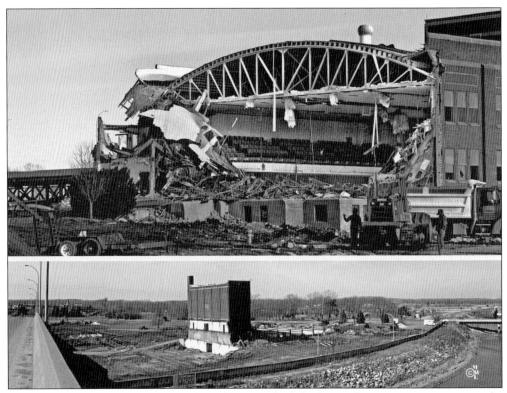

COLISEUM DEMOLITION. In 2005, the coliseum, which had served as a community center for more than half a century, was pulled down to create space for a new events center on the site. In the top photograph, note the stadium seating visible through the missing front of the building. In the middle photograph, taken from atop the Jefferson Street Viaduct, only the stage end of the building remains standing. The bottom photograph shows the stage section being demolished. Note the Jefferson Street Viaduct and Ottumwa High School in the background.

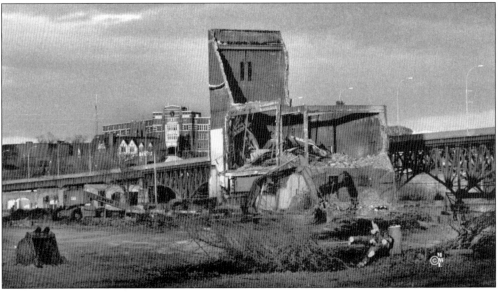

BRIDGEVIEW CENTER. After considerable debate among Ottumwa's residents since the beginning of the 21st century, a new cultural events center is being built on the site of the old coliseum on Market Street, just south of the Des Moines River. The center will offer a state-of-the-art theater as well as convention and conference facilities. This view shows the center under construction in May 2006.

HIGHWAY BYPASS CONSTRUCTION. A section of the long-awaited four-lane highway from Burlington to Des Moines nears completion as the bypass around Ottumwa is readied for paving. This photograph was taken in June 2006 from a new overpass on Bladensburg Road, looking toward the interchange under construction at Pennsylvania Avenue. For many years, Ottumwa was the only city of its size in the United States that was not on a four-lane highway.

ACROSS AMERICA, PEOPLE ARE DISCOVERING
SOMETHING WONDERFUL. THEIR HERITAGE.

Arcadia Publishing is the leading local history publisher in the United States. With more than 3,000 titles in print and hundreds of new titles released every year, Arcadia has extensive specialized experience chronicling the history of communities and celebrating America's hidden stories, bringing to life the people, places, and events from the past. To discover the history of other communities across the nation, please visit:

www.arcadiapublishing.com

Customized search tools allow you to find regional history books about the town where you grew up, the cities where your friends and family live, the town where your parents met, or even that retirement spot you've been dreaming about.